PHILADELPHIA

City of Homes

PHILADELPHIA

City of Homes

Photographs by the Author

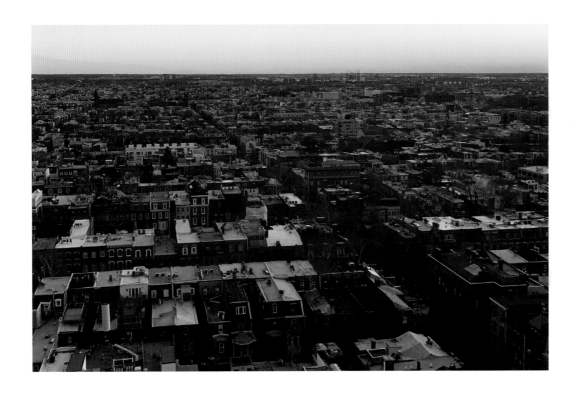

DAVID S. TRAUB

Foreword by Bruce Laverty

Camino Books, Inc.
Philadelphia

Printed in China.

1 2 3 4 24 23 22 21

Library of Congress Cataloging-in-Publication Data

Names: Traub, David S., author. | Laverty, Bruce, writer of foreword.
Title: Philadelphia: city of homes / David S. Traub; photographs by the
author; foreword by Bruce Laverty.
Description: Philadelphia: Camino Books, Inc., [2021] | Includes
bibliographical references and index.
Identifiers: LCCN 2021019272 | ISBN 9781680980493 (hardcover)
Subjects: LCSH: Dwellings—Pennsylvania—Philadelphia—Pictorial works. |
Architecture, Domestic—Pennsylvania—Philadelphia—Pictorial works. |
Philadelphia (Pa.)—Buildings, structures, etc.—Pictorial works.
Classification: LCC NA7238.P5 T73 2021 | DDC 728.09748/11—dc23
LC record available at https://lccn.loc.gov/2021019272

Jacket and interior design: Jerilyn DiCarlo

This book is available at a special discount on bulk purchases for promotional,
business, and educational use.

Write to:

Publisher
Camino Books, Inc.
P.O. Box 59026
Philadelphia, PA 19102
www.caminobooks.com

DEDICATED TO THE RESIDENTS OF PHILADELPHIA'S HOMES

Contents

Foreword

Bruce Laverty

City of Homes is a moniker shared by at least eight American cities, including such diverse places as Buffalo, Cincinnati, Baltimore, and of course, Philadelphia, Pennsylvania. Of all of these, Philadelphia is the one city that has the documents, the statistics, and the buildings to prove that it is indeed a *City of Homes*.

As early as 1893, an article in the nationally circulated *St. Nicholas Magazine* entitled "Philadelphia—A City of Homes" reviewed the positive impact of the 80,000 homes built here in the previous six decades. Its author credited these homes with "creating a higher civilization, as well as a truer idea of American home life, and are better, purer, and sweeter than any tenement house systems that ever existed. They are what make Philadelphia a city of homes, and command the attention of visitors from every quarter of the globe." Seven out eight Philadelphia families lived in "separate houses." In New York, by contrast, "only one family in six lived in separate houses."

Philadelphia's *City of Homes* motto, and its other popular slogan, *City of Neighborhoods*, are often overshadowed by another, uncontested title: *Workshop of the World*. In 1894, the Trades League of Philadelphia claimed that "Philadelphia was certainly intended by nature to be the great, thrifty manufacturing city it is… There are centered here the largest as well as the most varied assortment of manufacturing industries to be found in any city in the world." Volumes have been written about Philadelphia's great industrial production, but they invariably overlook the one product that for nearly three centuries consistently placed in the top 10% of its manufactured goods. That *product* was the single-family home. Between 1887 and 1893, the city produced 50,288 single-family homes; on average a new house completed every 27 minutes! Based on a conservative occupancy rate of five people per house, this seven-year building boom provided brand-new housing for 251,440 Philadelphians—fully one quarter of its population!

So proud was Philadelphia of this remarkable accomplishment that the city's contribution to the 1893 World's Columbian Exhibition was the model "Workingman's House." Designed by Philadelphia architect E. Allen Wilson, the two-story, three-bedroom rowhouse was so popular that crowds wore out its floor boards. In the heart of the Chicago's Beaux-Arts

White City, visitors were drawn by the tens of thousands to a simple red brick home—not for its great architecture, but for the modern miracle it represented: that "any industrious and frugal workingman living in Philadelphia may become a homeowner if he desires."[3] Clearly, Philadelphia's claim to the title, *City of Homes*, had substantial credibility which the world acknowledged.

The same industries that enabled Philadelphia's industrial laborers to own new row-homes, made it possible for clerks and foremen to own decent twins; for management to own single suburban homes in the neighborhoods of Germantown, Mount Airy, East Falls, Wynnefield, and Overbrook, and for factory owners to establish country estates in Philadelphia's Chestnut Hill and the Main Line suburbs. The industries are gone but the homes, humble and grand, in all states of restoration and ruin, remain as bricks-and-mortar evidence of Philadelphia as *The City of Homes*. With the eye of an architect and the talent of a master photographer, David S. Traub beautifully documents this evidence in the pages that follow.

Bruce Laverty, Gladys Brooks Curator of Architecture, Athenaeum of Philadelphia

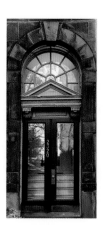

Acknowledgments

A s in all my books about Philadelphia, my astute photo editor, David Soffa, has played a wonderfully supportive role in bringing this book to publication. I am immensely grateful to him for his continuing service to me and could not have done it without him.

Leslie Miller and Holiday Campanella were of great assistance in meeting the technical challenges of formatting the initial drafts of the book.

Mary Morck was so kind to accompany and guide me on long trips through unknown neighborhoods in the great expanse of Northeast Philadelphia.

Many thanks go to Nancy Weinberg, who spent innumerable hours proofreading the text, and along the way suggested some good changes.

Scott Ryder and Douglas Ewbank, residents of Powelton Village, provided me with invaluable information about the architecture of their neighborhood.

William Whitaker of the University of Pennsylvania Archives provided important information about early twentieth-century modern architecture in Philadelphia.

Architectural historian Michael Lewis of Williams College shared with me his great knowledge of architect Frank Furness.

I am most grateful to Bruce Laverty, Curator of Architecture at the Athenaeum of Philadelphia, for his assistance in researching the Athenaeum's data base for information needed for the book, but especially for writing his superb foreword.

Margaret Chew Barringer was most helpful in providing information about her ancestor, Anne Sophia Penn Chew, whose house is shown in the book.

I owe a great debt to Joseph Minardi, author of three wonderful and comprehensive books about Philadelphia neighborhoods, who was always available to me to provide the history of so many of our city's homes.

Bill Whitaker has shared his incredible knowledge of the houses shown in the book located along North 51st Street in Wynnefield, the neighborhood where he lives.

My editor, Miriam Seidel, has meticulously combed over the book's text bringing it to the level worthy of submitting to the printer Her efforts were indispensable.

Accolades go to Jerilyn DiCarlo, a professional book designer who transformed the crude mock-up of the book into a refined pleasure to the eyes.

Finally, Edward Jutkowitz of Camino Books, my loyal publisher, who stayed with me as I have searched through the concealed city, followed me as I discovered Philadelphia's little-known places, and accompanied me in my travels through *Philadelphia, City of Homes*.

Introduction

You flagged walks of the city! You strong curbs at the edges...
You rows of houses! You window-pierced facades! You roofs! You porches and entrances!
You copings and iron guards! You windows whose transparent shells might expose so much!
—Walt Whitman, *Song of the Open Road*

In the simplest terms, cities are places for great numbers of people to gather together for a common good, both economic and social. Obviously, these people must have shelter of one kind or another, and in Philadelphia it is the single-family house that largely provides for that need. The single-family home is found everywhere, lining the streets and courtyards throughout the city, providing habitation for the people who perform the myriad occupations sustaining urban life. Even in the downtown of the original city planned by William Penn, two- and three-story houses are still found set down amidst high-rise buildings.

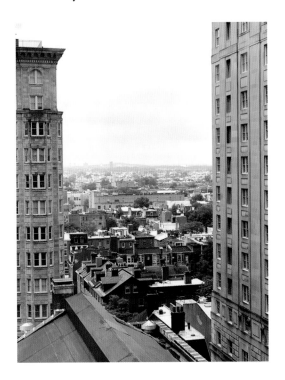

Compared to other large urban centers such as New York and Chicago, Philadelphia has relatively few apartment buildings. Of course, there have always been some, and in recent years more have been built. But the single house or house-like structure still prevails in the city's architectural profile.

Philadelphians want to live in a house. That is the thesis of this book. Philadelphians like to open their front door and step out onto a sidewalk along a street. It is a characteristic embedded in their urban genes. The resultant low-built spread of single-family homes provides Philadelphia with a sense of livability that should inspire the envy of other American cities.

Nevertheless, the single-family house does not take exactly the same form and style. This book identifies seven house forms: rowhouses which predominate, but also twins, courtyard and walkway houses, detached houses, mansions, unusual houses, and modern houses. Seven chapters illustrate these various house types in a range of historic styles, from early colonial to modern, but also as built in

a wide spectrum of neighborhoods across the entire city. Ranging from Somerton in the far corner of the Northeast to Eastwick at the extreme edge of the Southwest, and from Chestnut Hill in the Northwest to Packer Park in South Philadelphia, a selection of the city's houses appear here in color photographs.

The absolute rule followed for the book is that all of the houses shown must be within the city limits of Philadelphia, and all must still exist, never having suffered demolition. The reader should keep in mind, given the limitations of a book of this length, that what is shown here constitutes but a tiny sampling of the tens of thousands of houses within the huge city. Regrettably, many more potential examples are not included.

I must confess that the houses selected are among those that hold a particular personal interest for me, and may not be the ones chosen by another writer or reader. Nevertheless, I hope the book will inspire readers to take their own self-guided tours, walk about or drive around the expanses of the city, into absolutely every neighborhood, and find the single-family houses that are intriguing to them.

Be assured that this book does not stop at showing houses only in the oldest and most historic districts—houses in newer sections such as Packer Park and Parkwood are shown as well. Residences in affluent neighborhoods and the poorest are depicted here. Fashionable neighborhoods such as Society Hill and Chestnut Hill are shown alongside struggling districts such as Logan and Frankford.

The reader may be surprised to find, in browsing through a book about houses, that so many streetscapes are depicted. But a book about the houses of Philadelphia is inevitably a book about its streets. With the plenitude of rowhouses, and by their very nature, connected as they are to one another, extended streetscapes are formed. These long, unified streetscapes are a feature that defines Philadelphia's character, a fact which this book emphasizes.

Despite the ubiquity of the rowhouse, there are some neighborhoods where one finds many detached single-family houses. In Overbrook, East Falls, East Oak Lane, and Chestnut Hill, houses stand alone surrounded by front, side, and back yards, similar to houses in the suburbs. Driving from a rowhouse neighborhood into one of these leafy precincts, one is startled by the change in atmosphere. Old Somerton, in the far northeast corner of the city, presents to us the very image of an American pre-World War II suburb. Off Grant Avenue near Holy Family College, in the Torresdale neighborhood, there is a small pocket of large single-family, detached houses with spacious well-kept yards and tree-lined streets. Likewise, also in the Northeast, not far from Oxford Circle and the Roosevelt Boulevard, there is Northwood, another such verdant oasis with detached houses.

Speaking of Northeast Philadelphia, we should acknowledge that there is no other section of the city that so strongly illustrates the pervasiveness of the single-family dwelling. From the River Wards of Fishtown and Port Richmond in the Lower Northeast, to Somerton and Parkwood in the distant reaches of the far Northeast on the border of Bucks County, single-family houses spread out inexorably. We are speaking about a stretch of fourteen miles of essentially single-family houses. From the Northern Liberties section up to the Mayfair neighborhood, there are mostly attached rowhouses and twins. Beyond Mayfair, in neighborhoods such as Bustleton and Rhawnhurst, there are sections of one- and two-story detached

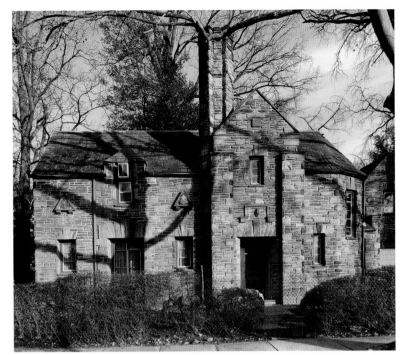

Northwood Street, Northwood Neighborhood, Northeast Philadelphia

Primrose Street, Torresdale Neighborhood,
Northeast Philadelphia

houses pushed so close to each other, with such narrow side yards, that they could almost be attached. Crossing busy Woodhaven Road, below the Roosevelt Boulevard, new post-World War II brick rowhouses proliferate in the Parkwood neighborhood.

In this whole expansive section of the city, which could be a city unto itself (and in fact, there has been a movement in the Northeast to separate from the city), there are no high-rise buildings. There are apartment buildings, but they are low-rise constructions of no more than four or five stories. Only forested Tacony Creek and Pennypack Parks, the Northeast Philadelphia Airport, and some shopping centers interrupt the flow of houses that otherwise surges across the district. Certainly, the other sections extending out from the center—South Philadelphia, West Philadelphia, and North Philadelphia—are very densely packed with houses. But as very large as those sections are, they are still small in comparison to the vast area of Northeast Philadelphia with its plethora of single-family houses.

Also worth mentioning are sections in the Northeast where numbers of rowhouses, twins, and small detached houses stretch out practically as far as the eye can see, amazingly without the insertion of commercial amenities of any kind. There are no little corner stores such as one finds in South or West Philadelphia. The residents evidently must drive to the shopping centers and traditional business streets, such as Torresdale or Rising Sun Avenues, though these streets, as often as not, are in decline.

Natalie W. Shivers writes in her book, *Those Old Placid Rows*, "Every city has been confronted with the puzzle of fitting the most people into the least amount of space—preferably in a manner that is both comfortable and handsome." While Philadelphia is blessed with a

large area within its boundaries, that space still is not unlimited. The problem has been solved in Philadelphia by employing closely packed, low-rise residential construction in its multiple variations. This has provided the city with what the author terms a "horizontal density," while urban areas like Manhattan embody a "vertical density." Driving through the city from Somerton to Eastwick, a distance of 25 miles, one is given the illusion that Philadelphia is much larger in population than it really is. Philadelphia has a population of only about 1.5 million, compared to New York City's 8.5 million. Spread over a tremendous area with closely spaced single-family houses, Philadelphia appears to be the extremely populous metropolis it is not.

Philadelphia has been called the *City of Neighborhoods*, and without question it is that. However, in the author's view, that moniker does not uniquely characterize Philadelphia. Most if not all American cities are structured by a collection of neighborhoods, each given a name. If anything, the special form and flavor of each of the neighborhoods comprising the city is the result of the gathering of houses within it. Seeing Philadelphia as a city of homes gives a deeper understanding of a place that is known for its intimate feel. It is the nudging of one relatively small, single-family house against another that can stimulate the close human interaction that is the wellspring of intimacy.

In the 1920s, Philadelphia was proudly called "the City of Homes." For some reason, the slogan has been discarded, but I propose that "City of Homes" would represent, to the resident and the visitor alike, a better understanding of the underlying character of the city. And perhaps the use of this moniker might tend to attract greater numbers of visitors curious about why it is so called.

The purpose of this book, then, is to give readers a panorama of the vast spread of single-family houses in their various forms that create the unique neighborhoods across the expansive city, thus prompting them to agree that Philadelphia, most properly, should once again be called *The City of Homes*.

David S. Traub

Philadelphia Has Close Upon 400,000 Separate Homes

THE greatest fame of Philadelphia is expressed by its title, "The City of Homes."

There could be no fact more indicative of the contentment, comfort, health and prosperity of its people.

Within the city limits there are close to 400,000 separate residences. A brief calculation, comparing this with the population, will show that *virtually every family in Philadelphia lives in its own individual home.*

There are practically no flats. New York, by contrast, has 3,500,000 people living in tenements and apartments, and can boast of less than 125,000 one-family houses. Philadelphia has three times that number of one-family houses.

Most of these Philadelphia houses are of two or three stories, and only 13,000 are of frame construction; the rest, brick and stone.

Still more significant is the fact that 125,000 of these houses are owned by the families who occupy them. Building and loan associations have conspired with the natural thrift and energy of Philadelphians to make this ideal condition possible.

It was in Philadelphia that the idea of such organizations originated, and Philadelphia has carried out the idea to the fullest and most practical point. There are today more than a thousand of these associations in the city, and no family with the desire for a home of its own need lack for one.

Page from Historic Philadelphia, *1922, The Public Ledger Company, Philadelphia*

Rowhouses and Townhouses

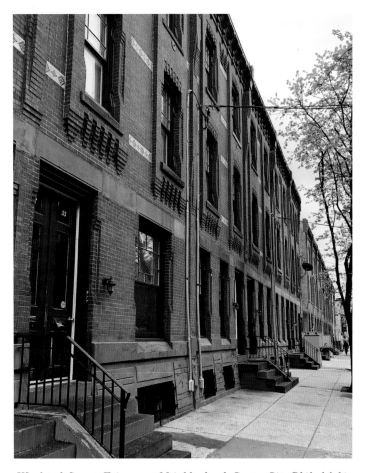

Woodstock Street, Fairmount Neighborhood, Center City Philadelphia

The rowhouse is virtually synonymous with Philadelphia. The architect, artist, and writer Alfred Bendiner wrote in his book, *Bendiner's Philadelphia*, "the row house is the backbone of Philadelphia city living. There are so many examples of rowhouse architecture that even the archaeologists can't make up their minds which is the best." In fact, there are more than 400,000 such dwellings on thousands of blocks of the city. Nearly 70 percent of Philadelphia homes are rowhouses, easily more than any other type of single-family house. Only the city of London, England has more rowhouses.

Rowhouse building began in Holland in the fifteenth and sixteenth centuries. In cities such as Amsterdam and Delft, attached urban houses flourished, built with brick and adapting classical form and details originating in Renaissance Italy. The style spread to England in the seventeenth century and then to the Americas, as colonists brought their architectural traditions to the New World.

Pictured here is a row of handsome, red brick, late-Victorian rowhouses that could have been lifted off a street in the west part of London. Their flat facades crossed by bands of stone and glazed tile are further embellished by virtuosic flairs of decorative brickwork.

Philadelphians like to call their beloved rowhouses "rowhomes." This colloquialism reveals much about the inhabitants of these ubiquitous dwellings. The rooted Philadelphia denizens of the rowhomes tend to be a special demographic devoted to their sixteen-foot-wide attached structures, their families, and their neighborhood. They are a population disappearing in the United States, where the dream for most is to live in a freestanding house in the suburbs, surrounded by as much green lawn as they can afford. On the other hand, a generation of young people who in the past would have stayed in the suburbs, have discovered the pleasures of city life and have been returning to the city, settling into the plentiful stock of rowhouses. from which others have moved away. Alfred Bendiner writes again, "rowhouse living isn't so difficult to comprehend. It is for people who like living in the city at street level."

There are residences in Philadelphia that, in actuality, are rowhouses, but are given another name. They are called townhouses. How might we distinguish a rowhouse from a townhouse? This is a most challenging question. It requires a nuanced answer having to do with architectural style, the specific location of the house within the city, and the social-economic class of the inhabitants. Is the answer somehow a subtle mix of all three factors? For example, a three-story house on the 2100 block of Delancey Place in the Historic Center is a townhouse; although it is no bigger or significantly different in basic style than a house on, say, South 15th Street which would ordinarily be referred to as a rowhouse. To be sure, the residents of the 2100 block of Delancey Place are relatively affluent and the houses there have a slightly added increment of architectural style. These factors perhaps elevate the structures to the status of "townhouse." It might be added that as of the writing of this book, striking new townhouses are being built on valuable empty lots, inserted between high-rise buildings in the business district, in the very heart of Center City. These houses cost in the millions of dollars, but there are townhouse-loving buyers who will pay for them.

By definition, rowhouses have no side yards. And closely fronting the street, they usually have no front yards. What they do have, though, is an open space to the rear of the dwelling, albeit in most cases rather small. In Philadelphia, this space is called a "garden," not a back yard.

Some of these are patios with lush plantings; others are bare and utilitarian, but this bit of space open to the sky is a possession cherished by rowhouse owners.

Many neighborhoods abounding with rowhouses have gone through transformations, providing homes for wealthy residents, slipping back into enclaves lived in by low-income populations, and then turning back to neighborhoods of the more affluent. The Society Hill or Spring Garden neighborhoods would be good examples of this phenomenon. And it is to the credit of the rowhouse form and design that it survives these urban vicissitudes and works successfully for diverse classes of people. Sir Osbert Lancaster, the English architectural writer, observed that "the ability to survive drastic social reversals forms an acid test for good architecture." The traditional Philadelphia rowhouse has stood the test of time as a durable architectural form of great value, at least up to the present. However, in the second decade of the twenty-first century, the form and look of the rowhouse changed as never before in three centuries. This evolution will be discussed in Chapter Seven, Modern Houses and the *New Vernacular*.

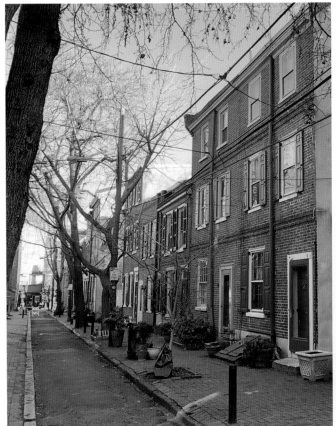

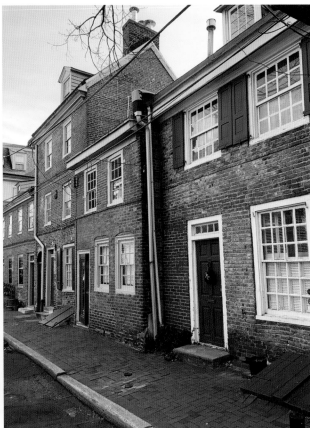

South Side, 100 Block of Fitzwater Street,
Queen Village, South Philadelphia

North Side of Fitzwater Street

Queen Village was first settled by the Swedes in the 1600s, even before William Penn's arrival. Formerly known as Southwark, it is Philadelphia's oldest neighborhood. Fitzwater Street, on the first block west of Front Street, contains some of the oldest rowhouses found in the area, with some dating from the 1690s. Many have projecting rows of brick, called string courses (see photos) between the first and second floors. This is a stylistic feature confirming that the houses are of an early vintage. While most Philadelphia rowhouses stand in perfect alignment with the street, these structures step back and forth at varying heights. This feature gives an appearance suggesting a less-organized medieval streetscape, while still maintaining a sense of cohesion. Christopher Morley writes of such places, "If I were an artist I should love to picture the quaint huddle of tawny red brick, the vistas of narrow little streets, the corners and angles of old houses." The lesser-known block competes with Elfreth's Alley and Cuthbert Street in Old City for an atmosphere of charming antiquity.

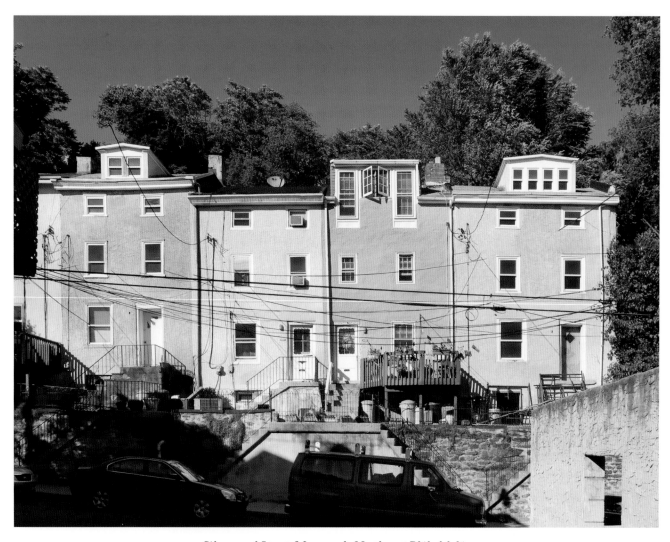

Silverwood Street, Manayunk, Northwest Philadelphia

Notched into a verdant slope of upper Manayunk, this row of tall houses displays a subtle range of colors—tan, cream, gray, and beige—set off by the green backdrop of trees. Raised extremely high above the street, the front doors are reached by steep, double flights of steps. The steps themselves are a striking architectural element in the total composition. The dormers with their stretches of windows are like eyes that take in the dramatic view to the west, across the Schuylkill River to the Belmont Hills beyond.

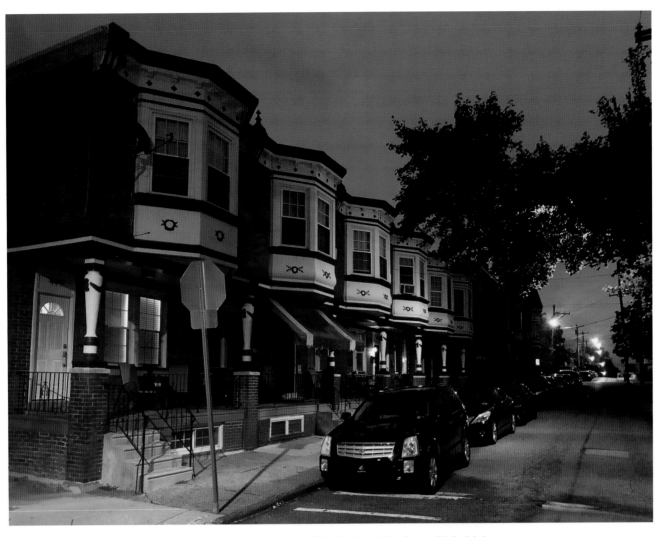

Mitchell Street, Roxborough Neighborhood, Northwest Philadelphia

Streaming down the street, this beautifully painted, well-kept row shines in the early evening. A sense of community is evidenced by the uniformity of the color scheme. Traditional angled bays project out over the recessed porches, affording eyes on the street. The second floors over the porches are supported by diminutive, decorative columns fastened to brick piers. These curious features, appearing all over the city, seem to have been fabricated by a particular metal shop and supplied to builders for their speculative developments.

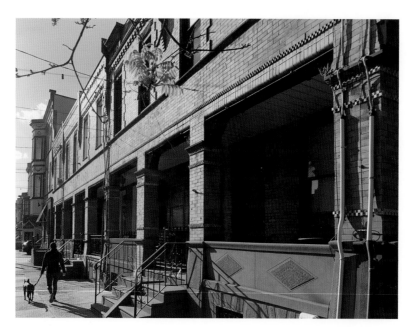

Wolf Street, Lower Moyamensing Neighborhood, South Philadelphia

Starting at South Street and stretching six miles down to the stadiums beyond Packer Avenue, South Philadelphia is still not nearly as large as the Northeast. Yet no other section is as densely packed with rowhouses on crisscrossing narrow streets. Flying into the city to the airport over South Philadelphia, one sees the towers of Center City suddenly rise up precipitously, cliff-like, at the end of the immense expanse of two- and three-story rowhouses. Extending a few blocks beyond South Street up to Spruce Street in Center City, the homey, residential community of South Philadelphia and Center City comes right up to the edge of the downtown business district and abruptly stops.

Here is a handsome South Philadelphia row, circa 1900, with porches recessed into the body of the house, unlike the typically projecting porches that are more prevalent throughout Philadelphia. Houses with this feature nonetheless appear in various locations across the city. The sturdy brick piers supporting the upper floor are circled with delicate glazed tile moldings. Along with the unusual broken metal cornice, the projecting brick details, and the shadowy porch, each house offers us in its total composition a fine piece of architecture in miniature.

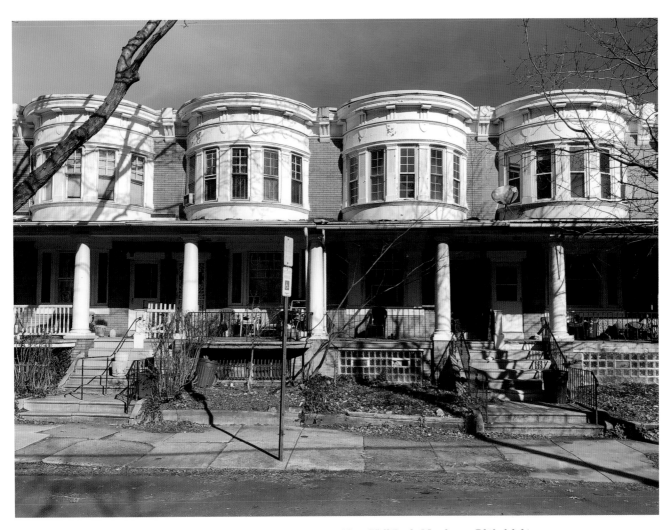

Morris Street, Lower Germantown near Fern Hill Park, Northwest Philadelphia

These handsome, well-kept rowhouses, built circa 1910, parade proudly down the street. The half-round second-floor bays are an unusual sight in Philadelphia, where most such bays are either angled or rectangular. A series of tall, narrow, well-proportioned windows wrap around the bays, capped by restrained, elegant cornices. Below are the shadowy recesses of the porches, reached by short flights of steps. Providing visual support to the curved bays, and actual support to the porch roofs, are fluted columns topped with Doric capitals. Except for the tan brick, all other elements are painted a pristine white, striking to the eye against the deep blue sky.

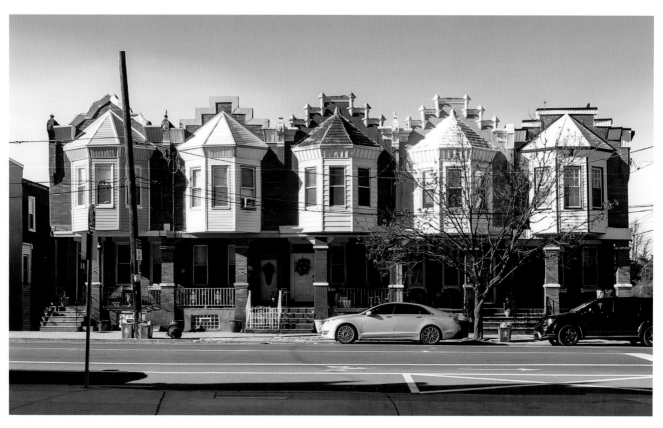

33rd Street at corner of West Lehigh Avenue, Tioga Neighborhood, North Philadelphia

Here is a most unusual stretch of rowhouses that seemingly demonstrate the desire of their builders to make an impression. Atop deeply recessed porches, angled bays almost completely cover the second-floor frontages. Crowning the bays are elaborate stepped cornices deriving from traditional Dutch architecture. Muscular brick piers lining the sidewalk support the heavy weight of bays and cornices coming down on the porches. One wonders if their inhabitants realize what exceptional pieces of architecture they live in.

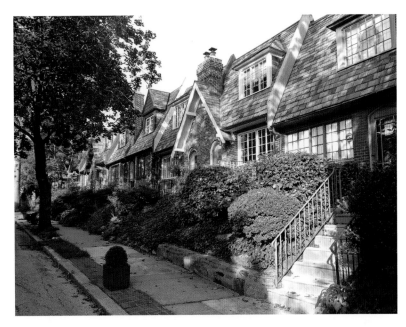

West Penn Street, East Falls Neighborhood, Northwest Philadelphia

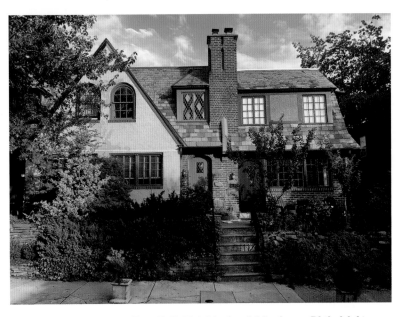

Midvale Avenue, East Falls Neighborhood, Northwest Philadelphia

Set back and elevated from the street, these houses with their quaint charm could have been lifted from an English Garden City of the late nineteenth and early twentieth centuries. The sloping front yards are fully planted with well-cared-for shrubbery. Fine materials—stone walls and slate roofs—provide a sense of quality. Each house is slightly different in design and detail, and yet as a set, they provide to the traveling eye a pleasing, coherent whole. The houses are included in the Tudor East Falls Historic District, which comprises one block each of Midvale Avenue, West Penn Street, and Queen Street (not shown). These blocks were developed in the East Falls neighborhood by Michael J. McCrudder between 1925 and 1931.

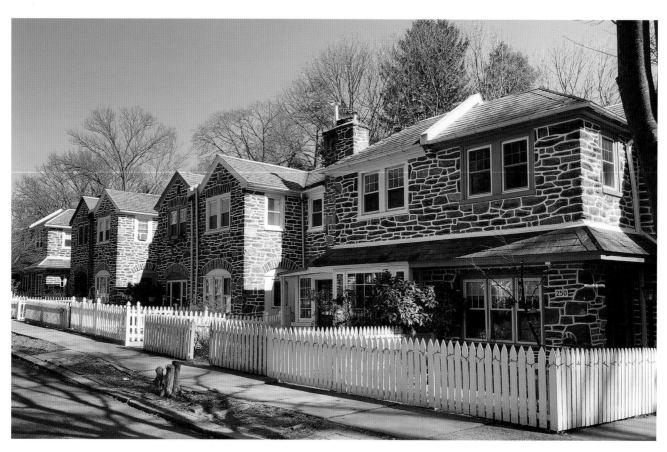

West Gorgas Lane, Mount Airy Neighborhood, Northwest Philadelphia

Unified by the stone exterior walls with white pointed mortar joints and the continuous white painted picket fence, this charming row proclaims particular livability for its fortunate residents. As they march down the lane, the houses display a unique, alternately coupled design of their rooflines, lending appealing variety to the streetscape. The street ends at a wooded area embracing a pathway that leads down to the SEPTA Carpenter Train Station, affording commuters to the busy city the privilege of a short walk back from the train to this tranquil enclave.

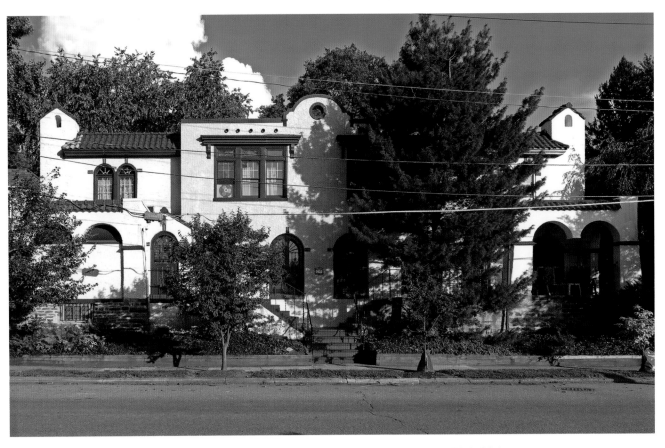

West Gowen Avenue, Mount Airy Neighborhood, Northwest Philadelphia

The houses of Philadelphia are generally based on the various traditions of English architecture, and the Northern European architecture of Normandy and the Low Countries has also played a role. But breaking into the pervasive spread across the city of house styles stemming from the cold climes, examples of more sunny Latin influences can be found here and there. Suddenly, we have traveled to a town in Spain away from the more staid and proper streets of the Anglo-Saxon city. Here are some of the most elaborate and varied of such rows. The historians call this style Mediterranean Revival, and amidst the vast array of more restrained styles, it is a welcome intruder.

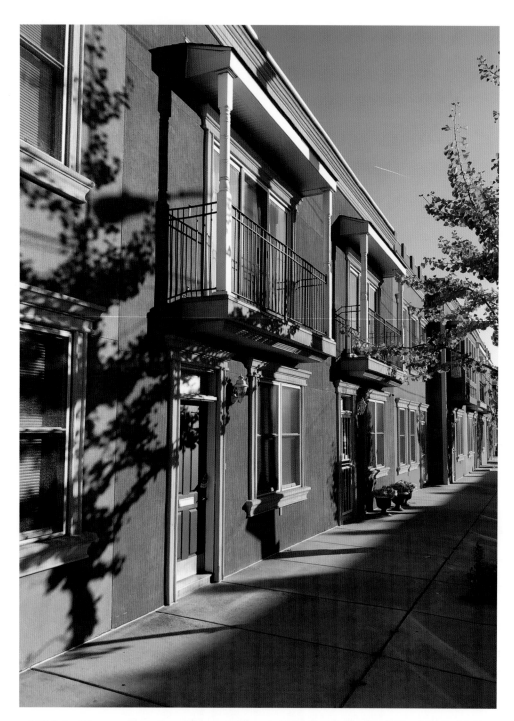

Bill Salas Way near Ontario and Glenwood Streets, Fairhill Neighborhood, North Philadelphia

Here are splendid new rowhouses built for a low-income Latino community in North Philadelphia. With their vivid coloration and expansive, covered balconies, these dwellings reflect the Caribbean architectural culture of the inhabitants. The two-story houses offer a gentle sense of scale, but the balconies provide them a quality of proud assertion. The street is named for Bill Salas, who has been a leader in the effort to provide economic opportunity and affordable housing for Philadelphia's Latino community.

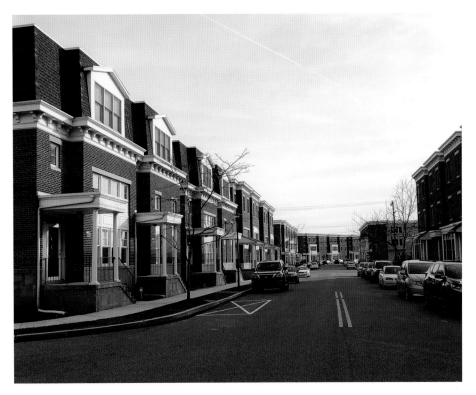

Siena Place, Packer Park Neighborhood, South Philadelphia

In far South Philadelphia, on the west side of Broad Street, are several developments built from 2003– 2008, continuing in their way the rowhouse and townhouse tradition of Philadelphia. The Reserve (seen below) was built in an adaption of the Georgian Colonial style, on the foundation of former naval housing demolished in 1995. Ample front yards and garages provide some of the amenities of suburban living while in close proximity to the offerings of a big city. The architecture of Siena Place (seen above) is more innovative in design, while retaining vestiges of traditional styles. The streets in both communities are named for places in Italy, reflecting the Italian-American population residing in the surrounding neighborhoods. It is worth noting that though the houses in both developments are in the rowhouse form and tradition, the developers have promoted them with the term "townhomes." So now there are rowhouses, rowhomes, townhouses, and townhomes. They all have two things in common: they are attached to one another in long rows, and they are all over Philadelphia.

The Reserve, Packer Park Neighborhood, South Philadelphia

ROWHOUSES AND TOWNHOUSES [*13*

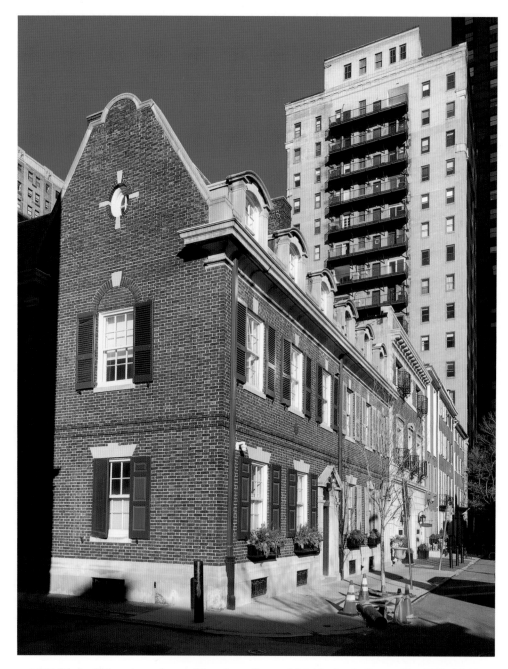

1700 Block of Rittenhouse Street, Rittenhouse Square Neighborhood, Center City Philadelphia

On this narrow street near Rittenhouse Square stands a group of attached residences in a range of classic styles including Neo-Georgian and Beaux-Arts. Though strung in a row, with their elegance and architectural distinction, they emphatically cannot be called rowhouses. They are without argument townhouses. A characteristic of this part of the city is the adjacency of townhouses to high-rise apartment and office buildings, such as those shown in the background of the photograph. This is an exceptional feature of Philadelphia, affording the stroller an experience of seeing old and new, tall and short, all mixed together in a fascinating combination.

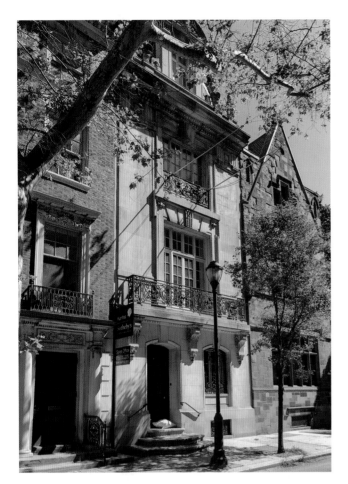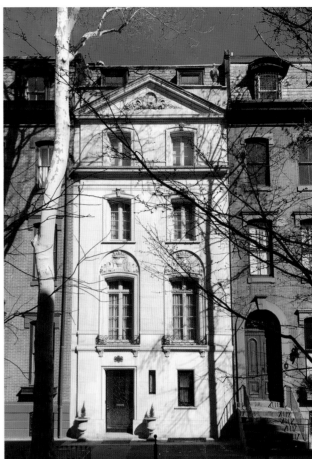

1600 Block of Locust Street (left) and 2000 block of Delancey Place (right), Rittenhouse Square Neighborhood, Center City

Though positioned in a row of attached houses, these two dwellings clearly fit into the townhouse category. With their architectural distinction, they could never be called rowhouses in the vernacular mode. Both were designed in the French Beaux-Arts Style by distinguished architects early in the twentieth century. Constructed of stone rather than brick and including exquisite details, they emphatically display the affluence and taste of their original owners.

The Locust Street house was designed by famed architect Horace Trumbauer (1868-1938). It is one of the few townhouses of his design found in Philadelphia. The decorative ironwork at the entry door and balconies was executed by the legendary artisan, Samuel Yellin (1885-1940.)

The Delancey Place house was designed by the firm of De Armond, Ashmead and Bickley, lesser-known architects but distinguished in their way by excellent residential design which can be seen throughout the Philadelphia region. The house had been the residence of Pearl Buck, the famed author of *The Good Earth*.

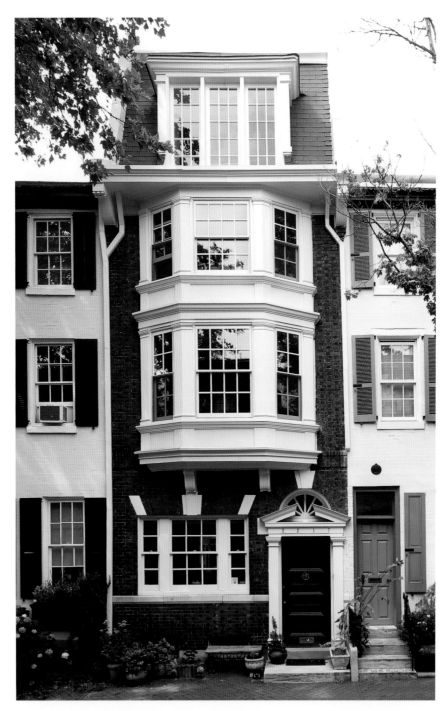

Rittenhouse Street, Fitler Square Neighborhood, Center City Philadelphia

Inserted between more traditional rowhouses, this dwelling too must be called a townhouse by virtue of the fine architectural elaboration on display. The cornice beneath the fourth-floor mansard projects forward to capture the stacked angled bays below. The ground floor is ennobled with a Georgian-style doorway and a variation of a Palladian window. A fanlight peeks through the broken pediment over the door. The brick is laid in a Flemish bond embellished with stone trim.

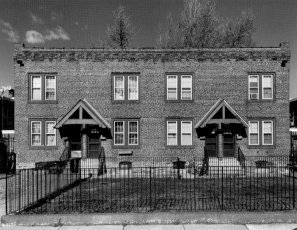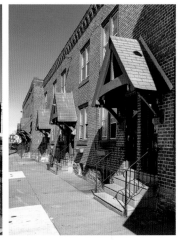

Octavia Hill Houses, East Cambria Street, Port Richmond Neighborhood, Lower Northeast Philadelphia

Octavia Hill (1838-1912) was a nineteenth-century pioneer of British housing reform. Inspired by Hill, the Philadelphia association bearing her name was founded in 1896 to address poverty and inadequate housing in the city. Existing to this day, the association has shareholders receiving modest profits. Although most such housing organizations are either non-profits or government departments, this profit-making organization has been amazingly successful in achieving its mission.

The association has for the most part dedicated itself to restoring existing houses in groups of three or more. The Beck Street courtyard shown on page 38 is a good example. As new construction built in 1918, the Port Richmond houses pictured here are an exception. The architect was John I. Bright (1869-1940).

Grouped around an interior courtyard, the Port Richmond houses are simple in design, built of fine materials, and well proportioned. The distinguishing feature is the gabled canopy over the twin entry doors, supported by brackets resting on a stone impost block inserted into the brick. This relatively inexpensive architectural device unifies and enriches the complex of 48 homes, providing a somewhat English feel that would please Octavia Hill.

The Compact House throughout the City

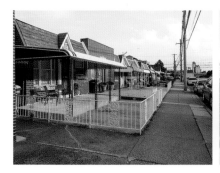 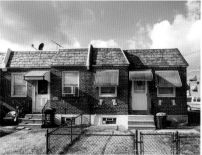

In the Far Northeast, South Philadelphia, and scattered around the city, there is a peculiar rowhouse type rarely found elsewhere in the United States. It is an exceedingly small species, only 20 x 20 feet (400 square feet) or less in dimension, on a single floor, sometimes with a basement level opening out into a sunken court or garage. A small front yard extends to the sidewalk. This is the Compact House. In South Philadelphia, they are colloquially called "baby doll houses." With a living-dining-kitchen area and a small bedroom, they are suitable at best for only a single person or a couple, no more.

In the years just after World War II, developers built these little structures on open land, knowing that there was a demand for inexpensive housing for people hoping to own a single-family dwelling. They were people who had a strong dislike for apartment living. These houses are one proof of the thesis of this book that Philadelphians want to live in a house of their own. They sometimes want this so very badly that they are willing to live in an abode of extremely diminutive size, a size that would otherwise be completely unacceptable to most Americans. For older people and singles, these dwellings can provide an ideal lifestyle offering amenity plus autonomy. These one-story "baby doll houses" are fitted into long rows creating a strikingly low-profiled streetscape, low even in neighborhoods that are already low-built. Fake gables, canopies, and chimneys break the monotony of their progress down the streets.

Providing very low density per acre, these houses do not offer an economical use of valuable land. In neighborhoods adjacent to Center City where there is a high demand for newer, more spacious housing, these tiny dwellings are being demolished and replaced with houses and apartments three or four stories tall.

A Gallery of Rowhouses throughout the City

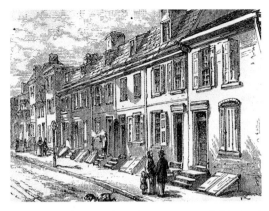

The quietness of these streets of quaint little houses is remarkable: in the golden flood of a warm afternoon they lay with hardly an echo to break the stillness.
—Christopher Morley

On streets stretching seemingly out to infinity, the city's 400,000 rowhouses display uncountable visages. Like people's faces, their facades show different complexions, different expressions, and different attitudes. Warm earth-colored brick is pervasive, but it ranges from a deep, rich red to lighter tones of beige and russet. Wood is there too, to be painted in hues as the owners desire. Some homes are flat-fronted; others feature recessed open porches. Still others have a projecting sun room. Impertinent gables poke up from level roof lines. Decorative flourishes are attached: the jewelry of the city. In each, a family lives, a newly married couple, a single person young or old. It is a way of life. Some residents will move out to the suburbs; but others, millennials, a yet-unnamed generation of young people, and immigrants from all over the world, will move in. The rowhouse builds Philadelphia. It is a constant. It enables hundreds of thousands of people to live in the boundaries of the city, without it resembling a tall-profiled metropolis like New York. Illustrating the point, here is a gallery of rowhouse streets as seen across the city identified by the neighborhood in which they are located.

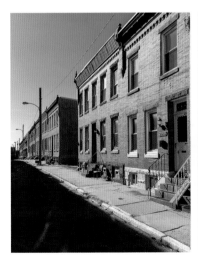

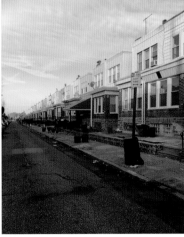

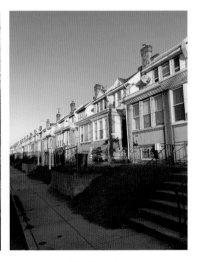

Kensington *Harrowgate* *Wissinoming*

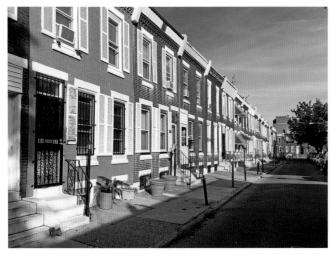

Port Richmond

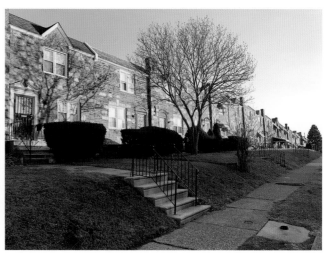

Mayfair

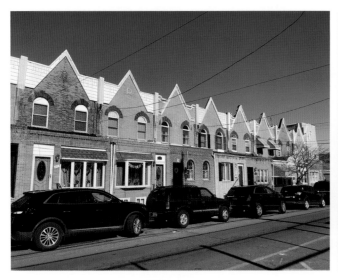

Whitman

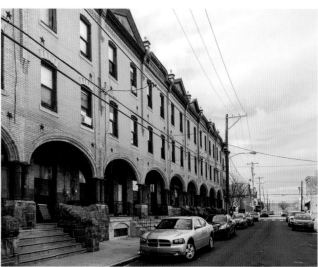

Strawberry Mansion

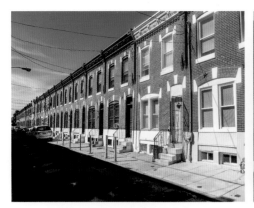

Kensington

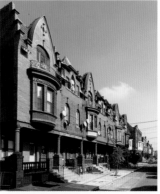

Parkside

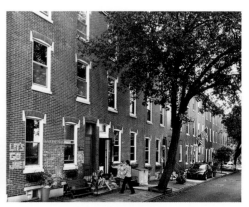

Fairmount

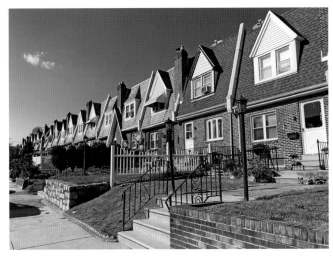

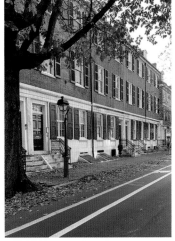

Holmesburg

Society Hill

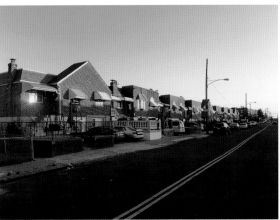

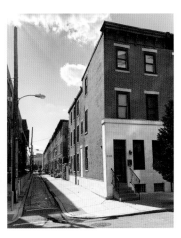

Rittenhouse Square

Juniata Park

Logan Circle

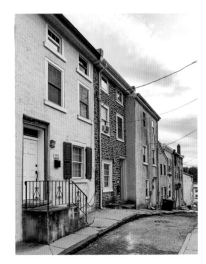

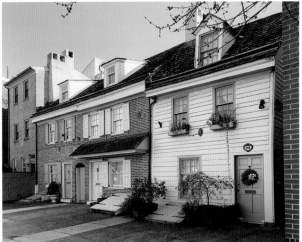

Manyaunk

Queen Village

Twin Houses

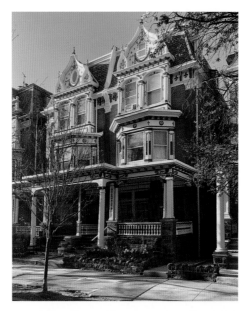

Twin houses, Pine Street, University City, West Philadelphia

There is a type of dwelling common in Philadelphia that is neither a rowhouse nor a detached house: it is the semi-detached house. Philadelphians called them twins. Outside the center of the city, in the Victorian neighborhoods of West Philadelphia, in Mount Airy and Chestnut Hill in the Northwest, and in parts of the Lower Northeast, these duplet houses are very plentiful. Like Siamese twins, two houses are joined together side-to-side with a common party wall. The twins march down the street, with narrow open alleyways intervening between the pairs of houses leading to back yards. The two houses literally lie under one roof, as do the families dwelling within them. Little is heard of conflict between two such owners of the conjoined dwellings, thus serving as testimony to the general civility of Philadelphia's residents.

Why were so many twin houses built in Philadelphia in the latter decades of the nineteenth century and the early ones of the twentieth? Peering into the mind of a developer, one might discern the motive to provide a product appealing to an emerging buyer seeking to depart from the higher density of the rowhouse neighborhoods, while still providing the construction economies of two houses on a relatively small lot sharing a common wall. The twin is perhaps a residential compromise that mediates in Philadelphia between the rowhouse and the detached house of the city's several verdant suburban-like neighborhoods.

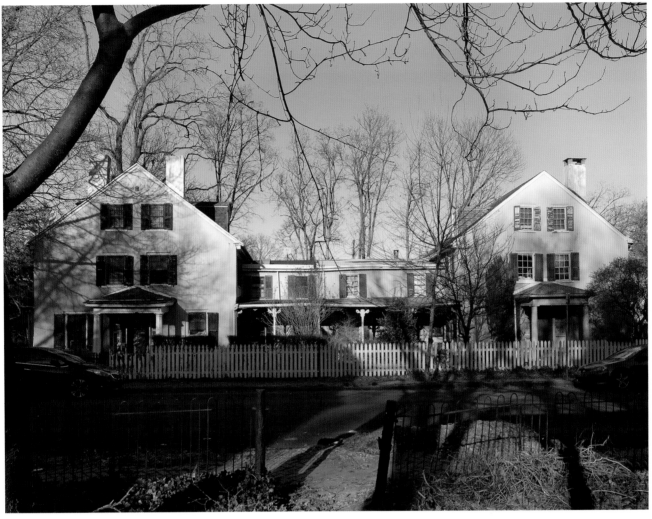

5301-5303 Knox Street, Penn-Knox Neighborhood within the Germantown Neighborhood, Northwest Philadelphia

Built more than a hundred years apart, these houses are not technically speaking twins. Still, it is appropriate that this unusual pair be shown here. The house on the right is the Pullinger House, built in 1790 in the Federal style, with a later 1863 rear addition set back from the main frontage. The house on the left was built in 1907 in the same style, matching almost exactly the older house, as a speculative venture by the Featherston sisters. Over the years, despite their original age difference, they have grown together, becoming a most amiable couple seemingly now of the same vintage.

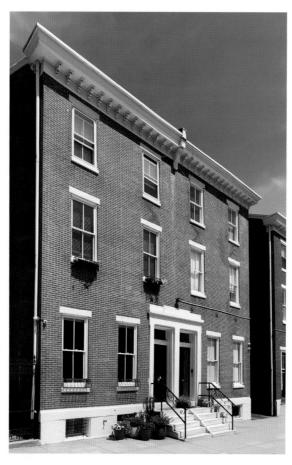

1600 Block of Green Street, Spring Garden Neighborhood, Center City Philadelphia

These noble Greek revival houses might just as well have been in a long row, but here they become twins, separated by narrow passages allowing light into the interiors through bay windows. The rich red-brick front facades supported on bases of marble are flat and as unornamented as can be. Here we see that projecting bays are not necessary to give a house interest. What does gives these houses great quality are the fine proportions of their overall mass, the vertical dimensions of the windows as they diminish ascending the facades, and the relation of solid-to-void they establish. The restrained design of the cornice and the elegant assembly of stone elements surrounding the entry door provide the only details. These tasteful refinements are attributes seldom found in recent house design in Philadelphia today.

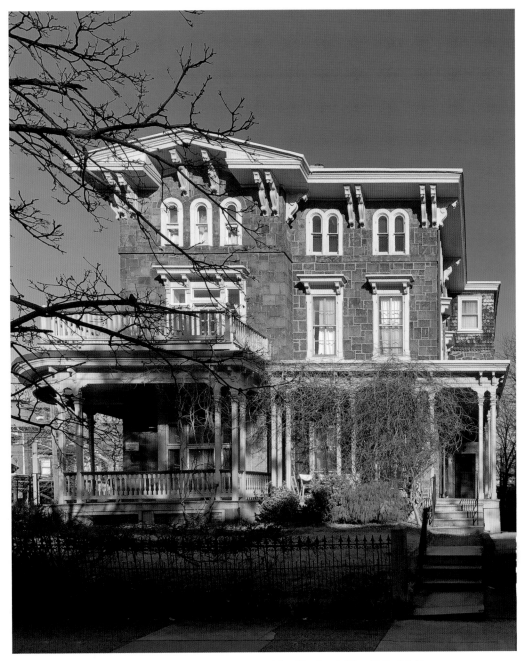

Woodland Terrace, University City Neighborhood, West Philadelphia

Not an identical twin, this corner pair is one of ten that make up the block-long enclave of Woodland Terrace, designed in 1861 by architect Samuel Sloan (1815-85) in the Italianate style. The enlightened developer was Charles M.S. Leslie, who also helped to create St. Alban's Place and Madison Square in Center City. French-born architect Paul Philippe Cret (1876-1945), designer of the Rodin Museum, who must have found the architectural ensemble most congenial, lived at 516 Woodland Terrace. Author Joseph Minardi points out that the designer has given the twins the illusion of being single-family mansions by placing the entry doors on the sides, set well back from the street.

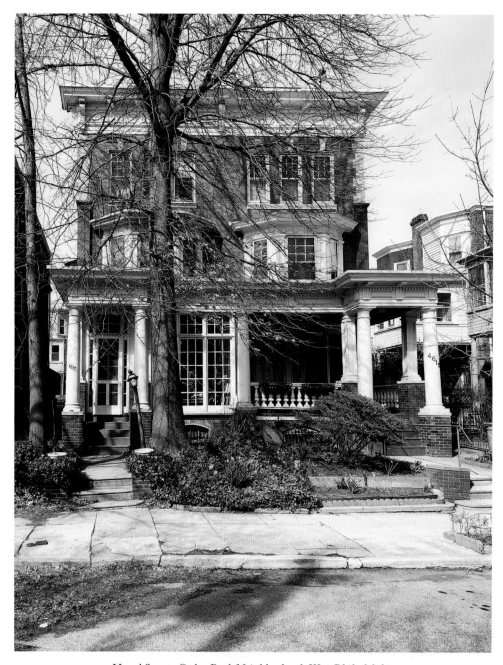

Hazel Street, Cedar Park Neighborhood, West Philadelphia

Cedar Park has a multitude of twins in the Queen Anne style, but this twin and those adjoining it are exceptions, built in the Georgian Revival Style also known as Colonial. Note the classical elements characteristic of the style: the cornices at various levels, Doric columns, and a balustrade. The front porches are stylistic anomalies in the neighborhood, though common among most other West Philadelphia twins. In this case, one of the south-facing porches has been enclosed by a glass multi-paned glass wall providing a sunny interior space. The symmetry of the twin is thereby altered in a pleasing way that gives spirit to the composition.

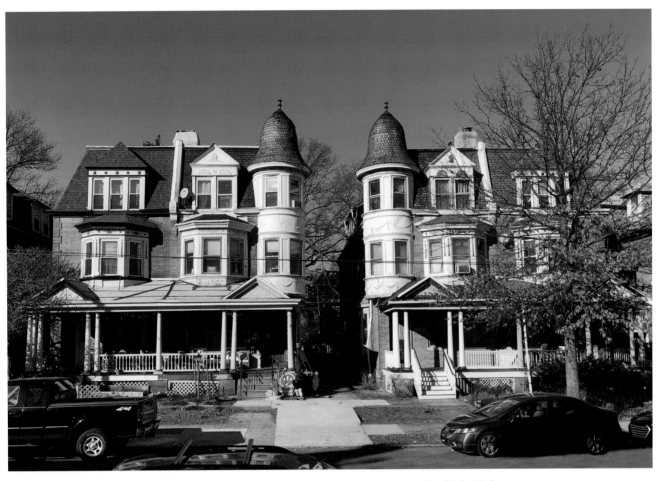

500 Block Cedar Avenue, Cedar Park Neighborhood, West Philadelphia

Of 1895 vintage, these Queen Anne-style twins suggest the comfortable lifestyle of the upper-middle class Victorians who occupied this streetcar suburb when it was new. Interestingly, individually the twin houses are not symmetrical but grouped in pairs, they create a picturesque symmetrical composition with the assistance of the end-positioned turrets surrounding an intervening side yard. The unusual bell-shaped roofs of the turrets visually soften what otherwise might be a jarring confrontation of the two castle-like features. Fortunately, the owners have cooperated with one another in selecting a harmonious paint color scheme that further unites the ensemble.

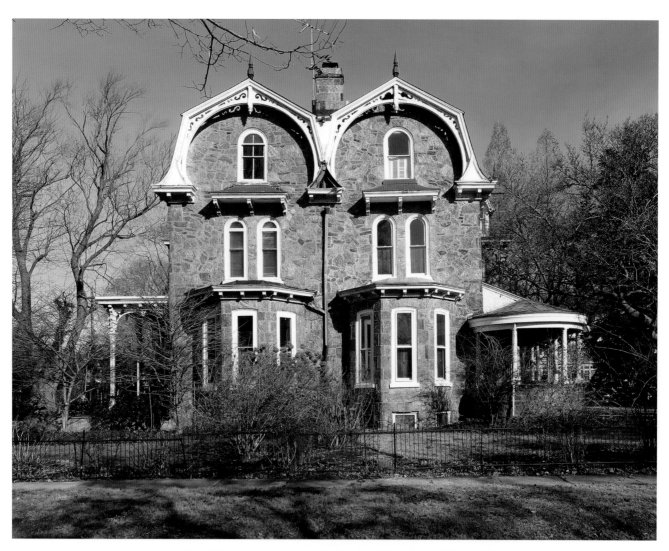

McKean Street, Germantown Neighborhood, Northwest Philadelphia

Whether identified as Queen Anne or High Victorian in style, these late nineteenth-century twins are among the most distinctive found anywhere in the city. The inventive, intricate wood arches crowning the roofs serve as both gables and cornices. In front, the angled bays resting firmly on the ground securely anchor the tall, narrow structures. Interestingly, even with the twins' strict symmetry, the side entry porches vary in their configuration—one rectangular, the other circular—lending tension to the composition. Spacious, verdant front and side yards provide a suitable stage for these unusual architectural actors.

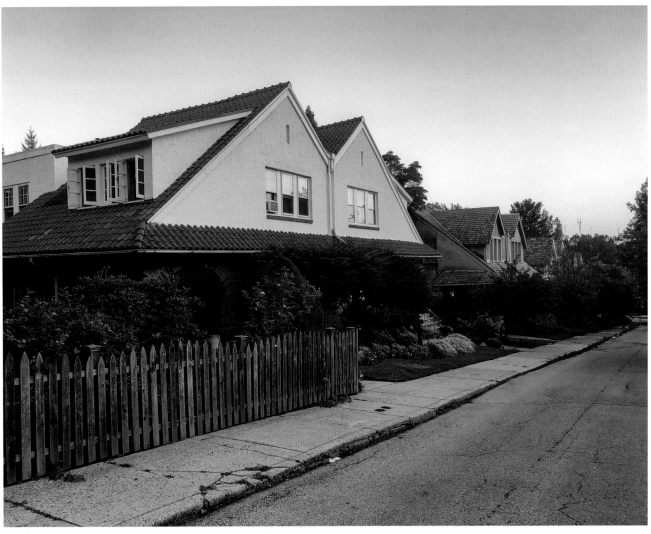

Rex Avenue, Chestnut Hill Neighborhood, Northwest Philadelphia

The Chestnut Hill neighborhood has much of the aspect of an English suburban town. One thinks of Hampstead, north of central London, which is placed comparably to Chestnut Hill, north of downtown Philadelphia. Both have picturesque shopping districts and surrounding residential districts with houses like these in the late nineteenth-century Arts and Crafts style and its variants, as seen in English Garden City developments of the time The twin houses here on this quiet byway are reminiscent in appearance to those of architect C.F.A. Vosey (1857-1941) and his British contemporaries.

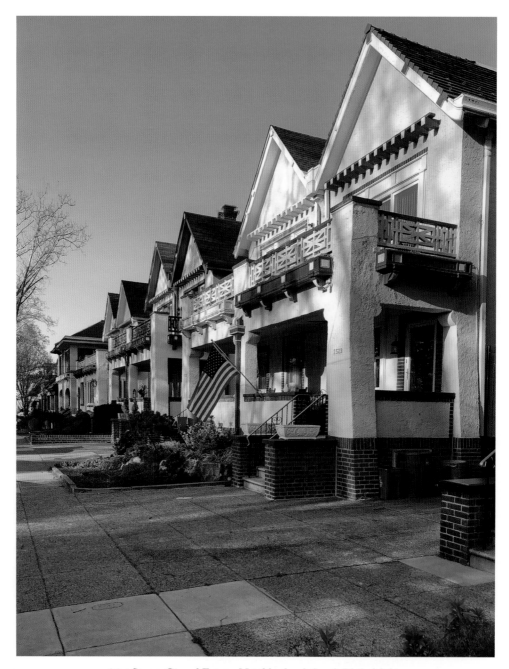

21st Street, Girard Estates Neighborhood, South Philadelphia

A book about Philadelphia's houses would not be complete without mention of the twins in Girard Estates. With the exception of a park and a library, the neighborhood is entirely residential, comprising 481 porch-fronted twins. They were designed between 1906 and 1916 by architects John and James Windrim in a style difficult to precisely identify, but which appears to be a mix of Mission, Bungalow, Jacobean, and Colonial Revival. Traversing the lower reaches of South Philadelphia, packed densely as it is with rowhouses, one is startled at coming upon this more spacious enclave with its tree-lined streets and broad sidewalks, offering the feeling of having entered another town.

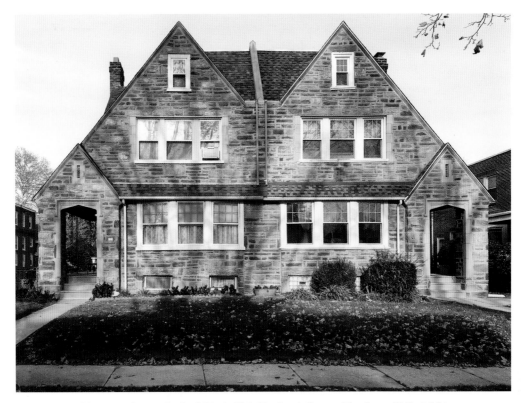

Glenview Street, Oxford Circle Neighborhood, Lower Northeast Philadelphia

This is a variant of the twin house type found scattered across the outer neighborhoods of the city. What appears to be a front entry is an archway that leads to a small open passageway. The actual entry to the house is through a door off the passageway at the middle on the side of each house. The advantage of this arrangement is that the occupant can enter the center of the house into a space with the living room to the front, and the dining room and kitchen to the rear. So, unlike the typical rowhouse, one does not enter directly into the living room or down a hallway to the back of the house which would take up valuable space. Another advantage is that the placement of the open archway at the front gives a welcoming feeling to the facade and becomes a pleasing element in the total composition. Across these handsome stone twins, bands of window stretch across the first and second floors, and a small, vertically proportioned window is inserted at the peak of the gables. A pent eave over the first-floor windows connects the two entry arches, which are topped by another but diminutive gable that matches the angles of the high roofs.

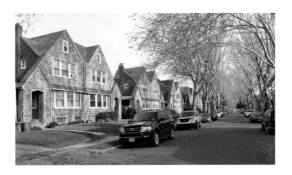

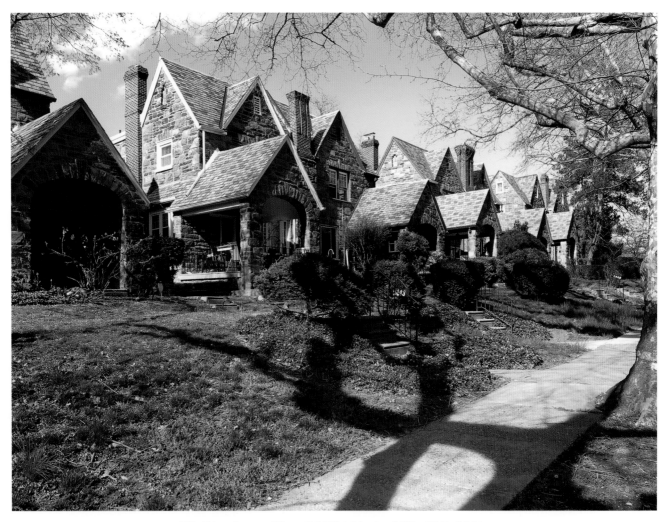

Woodbine Avenue, Wynnefield Neighborhood, West Philadelphia

These finely constructed stone twins built early in the twentieth century proclaim a comfortable hominess with their raised front yards, as if they are waiting for a happy family to move in: mother, father, and two or three children. Though not exactly providing the typical spacious suburban environment that so many Americans desire, they provide an economical compromise that may be a prototype for urban development in a future when space and energy must be conserved. Instead of the usual wooden front porch, the open sitting room is constructed of durable stone, with an arched entry and gabled roof matching those of the main body of the house.

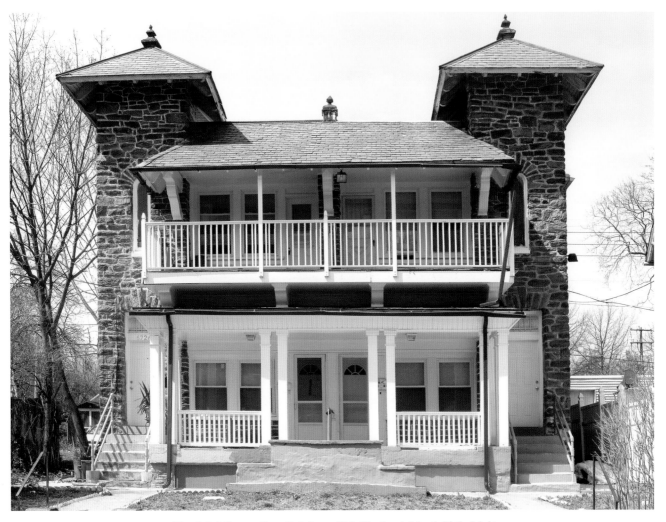

North 8th Street, East Oak Lane Neighborhood, North Philadelphia

This unusual structure is completely out of the Philadelphia mold. Though technically not a twin house, the building actually consists of two "duplexes" back-to-back, providing a total of four dwelling units. It nevertheless deserves inclusion in this book. Porches on the ground floor, and a projecting balcony supported by brackets extending across the facade, are framed by two stone towers capped by pyramidal roofs. One wonders what inspired the building's unknown architect to devise this unprecedented composition.

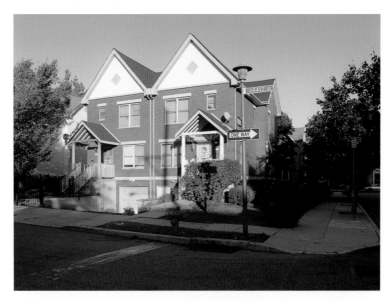

Gratz Street, Cecil B. Moore Neighborhood, North Philadelphia

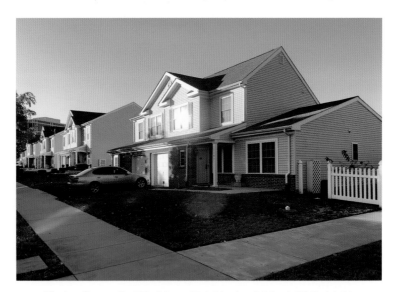

Harlan Street, Cecil B. Moore Neighborhood, North Philadelphia

Above are newly-built twin houses taking the place of deteriorated rowhouses in this largely African-American, lower North Philadelphia section which had been hollowed out by depopulation. Built in a pleasing traditional style with rich red brick as the dominating material, they assist in relating the houses to what is left of the surrounding red brick neighborhood. The welcoming gabled entry canopies echo the gabled roofs. Set back from the street, with garages tucked below grade and generous plantings of shrubbery, they make a good appearance from the street. Below are new twins in the same neighborhood, less sophisticated in design and unfortunately displaying less brick, but providing their occupants with the desired suburban amenities—roominess, a garage, and front lawn. Both represent, for better or worse, the appearance of a new order of urban development in this part of the city, where street after street was formerly densely packed with rowhouses.

Courtyard and Walkway Houses

Addison Court, 500 Block Addison Street, Society Hill Neighborhood, Center City Philadelphia

Courtyard Houses

One cannot imagine an American city that has more houses grouped around quaint courtyards and pedestrian-only, mid-block walkways filled with greenery. Laurence Lafore and Sarah Lee Lippincott write in their fine book, *Philadelphia: The Unexpected City:* "The courtyard was the first form of domestic arrangement in the early city and its use has persisted, here and there, in inconspicuous corners ever since, side by side with the more characteristic row." In centuries past, many of the old courtyards were where servants were given small houses tucked behind the larger dwellings of their employers. Now, these vestiges of another time have often been restored and serve as homes for people of all walks of life who seek a quieter and more intimate environment. The tradition of living in these cloistered places has extended into the present, as new residential courtyards and walkways have been built in many locations across the city in the decades after World War II and into the twenty-first century. Developers have wisely adopted this intimate form of planning, knowing that many of their buyers will desire to live in verdant sanctuaries tucked away within the city.

Walkway Houses

The idea of weaving pedestrian-only walkways into the fabric of the city originates in nineteenth-century developments such as St. Alban's Place and Madison Square in Southwest Center City. These tranquil promenades, free of the noise and fumes of automobile traffic, are a decided advantage for residents of a city as large and bustling as Philadelphia. Could it be that Philadelphians, with their more reticent temperaments, are particularly drawn to these places?

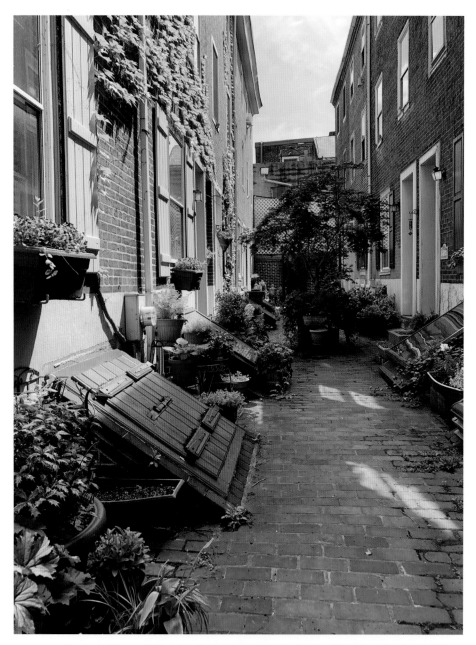

Hancock Court off Naudain Street, Society Hill, Center City Philadelphia

Scattered through the older parts of Philadelphia, in Society Hill, Queen Village, Washington Square West, and Fishtown, one discovers these curious, concealed, narrow courtyards, lined with "trinity houses." Trinity houses are so called because they have only one room on each of three floors: Father, Son, and Holy Ghost. Through wrought-iron gates opening off the wider residential streets, one enters a hidden world. In the past, they were dwelling places for working people or servants of those living in the nearby larger residences. Today, people of all classes have moved into these "microcosms of habitation" embedded in the core of Philadelphia. From these intimate, living environments, easy strolls are afforded to the close-by amenities of a big city: offices, stores, restaurants, and entertainment in all its forms.

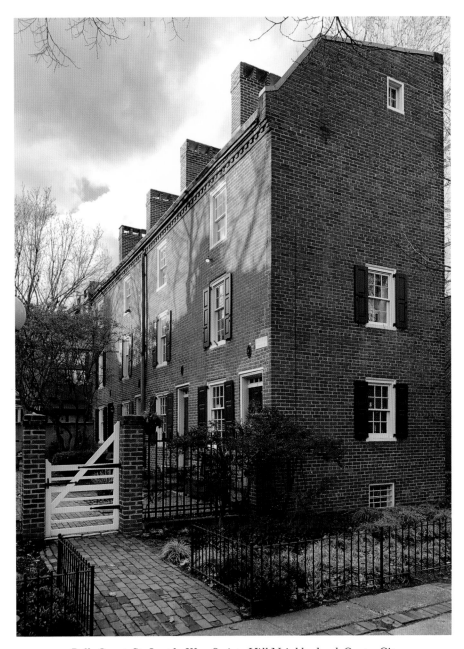

Bells Court, St. Josephs Way, Society Hill Neighborhood, Center City

This row of four trinity houses built from 1813 to 1815 line a small courtyard, accessed from a pedestrian-only walkway. These dwellings are the vertical correlative of the shotgun house, prevalent in New Orleans and Louisville, Kentucky, which is laid out horizontally, one single room behind the other. The half-story above, with the tiny window under the roof, is a loft that overlooks a third-floor bedroom. Built for servants and workers, these houses were built on narrow back streets and alleys behind their employers' larger houses on the main thoroughfares.

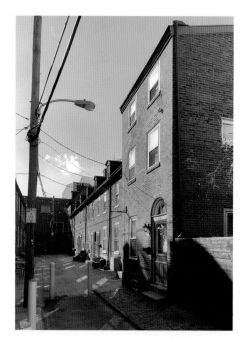

Beck Street, Queen Village, Center City Philadelphia

The entire 300 block of Beck Street was purchased by the Octavia Hill Association (see page 17) around 1930 and closed off with bollards to create a pedestrian-only courtyard. The intimate enclave is lined with fourteen two-and-a-half-story red-brick rowhouses facing North and South, all built before 1840.

Delancey Mews, Society Hill Neighborhood, Center City

Replacing a commercial building as part of the renewal of the Society Hill neighborhood led by planner Edmund Bacon and others, this intimate courtyard, the mews, was built in 1965 in colonial style. The houses are reproductions, but skillfully and tastefully crafted. Without argument, they fit well into their eighteenth-century context. A row of more houses of the same vintage front the 200 Block of Delancey. An arched opening in that row provides access to a concealed court providing parking. The wall shown to the left of the photo encloses the parking court with a gate affording access to the mews. As well, an alluring, narrow pedestrian-only passageway leads from 2nd Street into the mews, which provides a very tranquil, private living environment within the historic neighborhood.

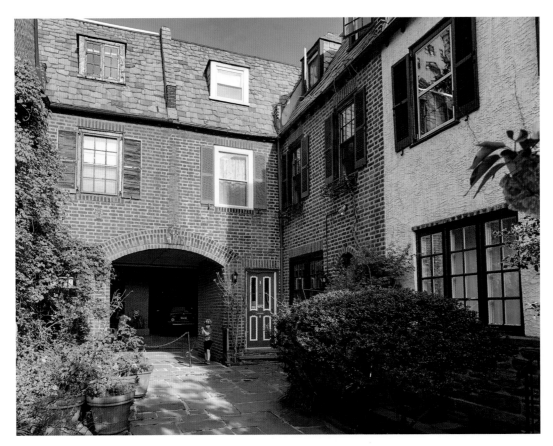

English Village, Fitler Square Neighborhood, Center City

nglish Village was designed in 1928 by architect Spencer Roberts. Entering it off 22nd Street between two stone pylons, the urban explorer sees at the far end of the court a shadowy archway supporting the second floor of two houses. Beyond is a dark, unknown place. Lured through the arched passageway, the wanderer comes into narrow, charming Van Pelt Street sealed off to the left, but is led out to Locust Street in the other direction. English Village then provides a sequence of unique places, to be explored in a dramatic procession through space and time that, if not experienced in reality, might best be captured in cinema.

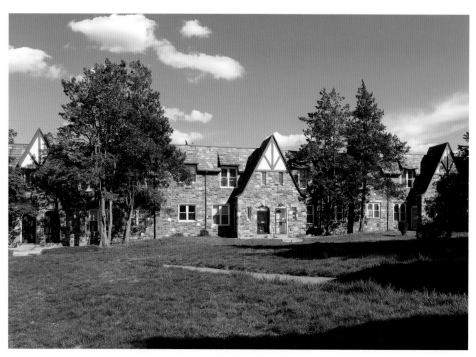

53rd Street and Montgomery Avenue, Wynnefield Neighborhood, West Philadelphia

The unusual elongated complex of Kevon Park, set back on a broad common lawn, provides a spacious setting for these dwellings in the otherwise densely built corner of Wynnefield. Variegated stone construction and slate roofs provide a sense of quality that would be costly in today's construction economy. The long row is punctuated by projecting gabled sections embracing the entry doors. At the peak of the gable, Tudor type half-timber and stucco detailing appears, adding an enriching feature to the architectural scene.

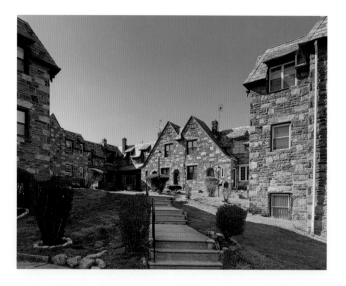

Across the street from the more linear Kevon Park is Kevon Garden, a grouping of similar houses which takes the form of an intimate courtyard. Both complexes appear to have been built about the same time by the same developer and architect.

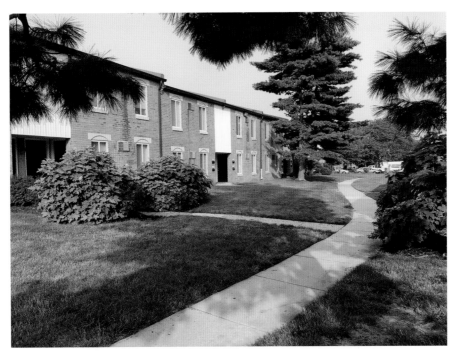

Walkway Houses, Eastwick Neighborhood, Southwest Philadelphia

At the farthest reaches of Southwest Philadelphia, not far from Philadelphia International Airport, is a vast new planned neighborhood. It was built on land provided by the demolition of a pre-existing neighborhood originating in the nineteenth century. The district had been one of the city's few integrated neighborhoods, with a population of around 19,000. Nearby swampy land called the Meadows was filled in to provide additional land for development. With the fervor of 1950s-era urban renewal, the older community was replaced with a new one designed by noted Greek urban planner Constantinos Doxiadis. Doxiadis's plan placed attached houses on winding streets and cul-de-sacs, with plentiful open space interspersed. Potential through traffic was funneled toward outlying peripheral roads. The success of the plan has been controversial, but the photo above shows houses set in a pleasant, green, vehicle-free environment accessed from a meandering walkway. The houses themselves, though not architecturally distinguished, are faithful to the rowhouse tradition of decades past.

Shady Eastwick Street

North Beechwood Street Walkway, Logan Circle Neighborhood, Center City Philadelphia

This pedestrian walkway provides an inviting path from Cherry Street to tucked-away Appletree Street. On the west side are a row of simple two-story dwellings. Instead of the typical Philadelphia red brick, the houses are built of white brick. The resulting light-colored facades offer a cheery brightness to the little byway. The overhanging trees on the east belong to Daniel Michaux Coxe Park, a tiny "vest pocket" public amenity designed by architect Norman Rice (see page 89). The entry to the park is not, as might be expected, from Cherry Street, but rather from the walkway, giving the charming urban corridor an additional purpose. Diminutive in actual size, the walkway and park together play an outsized role as a community space in this small-scale neighborhood, lying quietly in the shadow of Philadelphia's downtown skyscrapers just blocks away.

Daniel Michaux Coxe Park

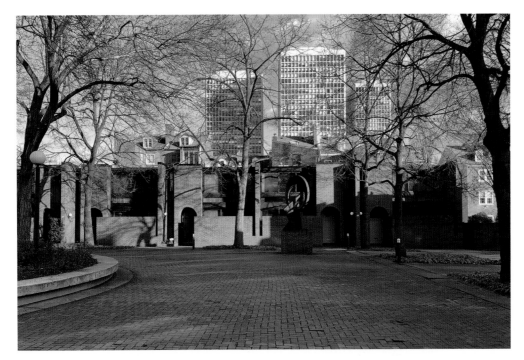

Bingham Court, Society Hill Neighborhood, Center City Philadelphia

This spacious court, though designed in a modern style in the 1960s by noted Chinese-American architect I. M. Pei, fits happily into Philadelphia's most historic neighborhood. The attached houses wrapping around walled courtyards suggest the traditional urban domestic architecture of Chinese cities that Pei would have known. Beyond are Pei's Society Hill Towers, which have become an iconic feature in the neighborhood, demonstrating a happy relationship of high-rise buildings to small-scale residential structures.

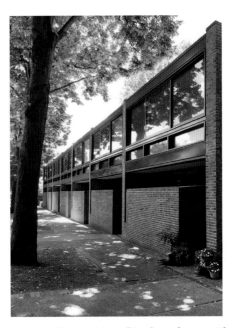

St. Josephs Way leads into Bingham Court with a
row of striking modern houses, also designed by I. M Pei.

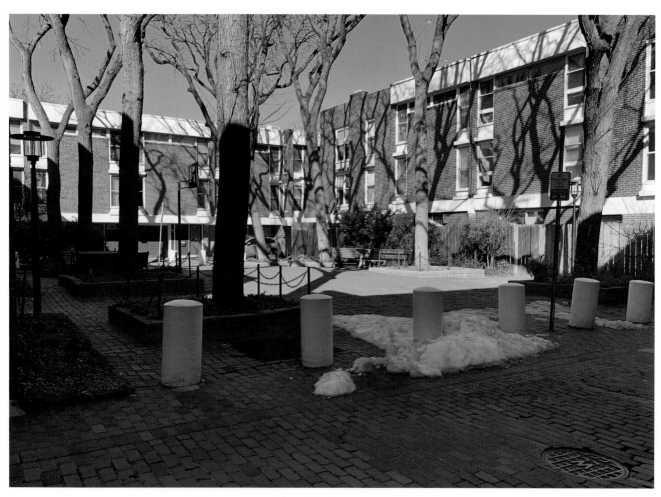

University Mews, Spruce Hill Neighborhood, West Philadelphia

Anchored firmly on the corner of 45th and Spruce Streets, this complex turns inward from the surrounding Victorian neighborhood. University Mews adroitly combines both walkways and a central, communal courtyard in a plan that was innovative for the time at its completion in 1962. The 46 brick-clad, modern townhouses designed by architect Ronald C. Turner provide a degree of privacy for the occupants. But unlike the gated communities of today, the walkways open out to the sidewalk, welcoming passerby into the charming enclave. Parking was provided for each house—probably a very enticing amenity for the first buyers— albeit in an unobtrusive way, recessed under the shadowing overhangs of the upper floors.

Detached Houses

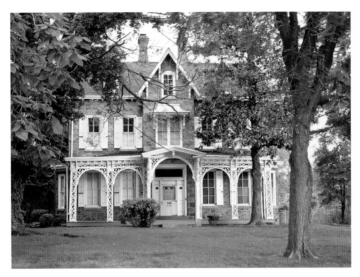

Church Lane, East Germantown Neighborhood, Northwest Philadelphia

Although attached houses—rowhouses, townhouses, twin houses, and courtyard houses—are easily the predominant habitations of Philadelphians, in scattered neighborhoods across the city, houses are to be found sitting separately, with open space around them on all four sides. These are the detached houses. Such houses are plentiful in the neighborhoods of Overbrook, East Oak Lane, Chestnut Hill, East Falls, and Somerton, to name some of them.

After driving through densely built rowhouse sections of the city, one is delightfully startled upon entering a street such as Warden Drive in East Falls to see such a vast change in urban conception. This gently curving street climbs uphill and is lined on both sides with large detached houses in a variety of styles. The lawns are filled with lush plantings and mature trees, giving a park-like impression. This and the surrounding streets are truly like a typical American suburb set down in the heart of the big city. This verdant enclave can be reached in minutes from downtown Philadelphia, following the Kelly Drive along the Schuylkill River.

Warden Drive in East Falls Neighborhood

Another experience characteristic of the city is suddenly finding a single block of larger detached dwellings amidst street after street of rowhouses. Finding a single detached house set down in an otherwise continuous row is not uncommon either. The Chestnut Hill neighborhood presents a good example of these features, as it displays modest rowhouses alternating with detached houses, and in some cases with mansions.

These detached houses display a range of styles including Colonial, of course, this being Philadelphia, but also Queen Anne, Tudor, Norman Revival, and Modern, to mention a few of the architectural variations. Many of the detached houses in outlying neighborhoods are built of stone in the Pennsylvania tradition, in contrast to the red brick construction of older neighborhoods in the center of the city. This chapter shows the spectrum of styles and material applications, while also revealing the range of house sizes throughout the city, from the smaller examples to the more standard-sized ones, while reserving the largest houses for Chapter 5, Mansions in the City.

The strikingly symmetrically composed stone house pictured at the heading of this chapter is in the Gothic Revival Style. A slightly projecting, narrow mass capped with a gable, rising the full height of the house, embraces the entry door at its base. The house's most distinguishing feature is the lacy, arched wooden colonnade reaching across the front of the house, forming a shallow porch.

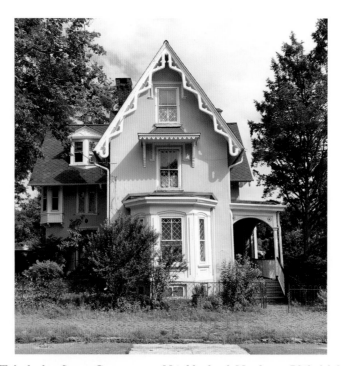

Tulpehocken Street, Germantown Neighborhood, Northwest Philadelphia

This charming Gothic Revival dwelling features verge boards, a kind of decorative wood fretwork, attached under the steeply pitched gable. Delicate trim adorns the canopy over the lone second-floor window that tops the ground-floor bay. Though the main walls appear to be stucco over masonry, there is so much wood elaboration that the home might be said to be in the Carpenter Gothic style.

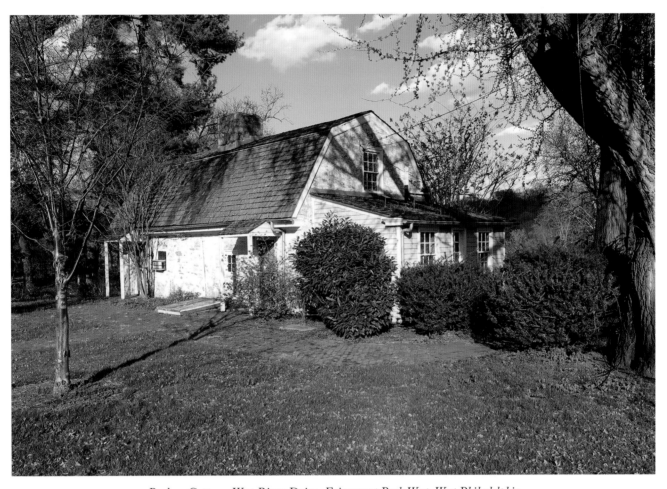

Boelson Cottage, West River Drive, Fairmount Park West, West Philadelphia

Built between 1678 and 1684, this is the oldest structure in Fairmount Park and possibly the oldest extant house in the entire city. The land is situated on a plot granted to John Boelson in 1677 by the Swedish colonial court in Upland, Pennsylvania. The Swedes had come to Pennsylvania even before the English and Welsh Quakers. The quaint cottage is in the Dutch and Swedish style, characterized by a gambrel roof: a variation of the gabled roof, but one with two slopes per side at different angles.

1548 Adams Avenue, Frankford Neighborhood, Lower Northeast Philadelphia

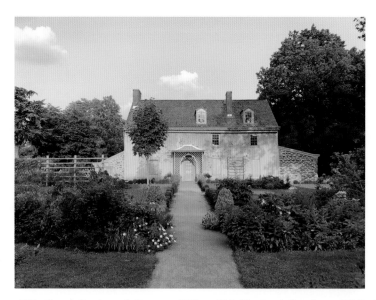

54th and Lindbergh Boulevard, Bartram Village Neighborhood, Southwest Philadelphia

Here are two very early Philadelphia houses, one humble and little-known, the other gracious and famous. The Worrel-Winter House is the oldest house in Frankford, built 1712–1718—predating the Elfreth's Alley houses. It is said that Thomas Jefferson read the Declaration of Independence there before issuing it in 1776. Built a little later, between 1728–31, the renowned John Bartram House with its botanical garden (the first in America), needs little introduction. Here it is shown in a less familiar view. Instead of the often-photographed rear facade facing the Schuylkill River, with its pilasters and single column fronting the middle of the recessed porch, the west-facing stone entry facade is shown bathed in golden rays of the setting sun, late on a summer day.

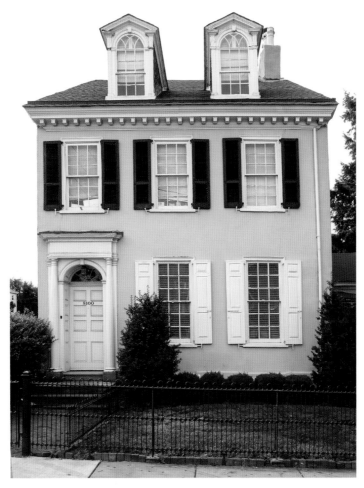

Frankford Avenue, Holmesburg Neighborhood, Northeast Philadelphia

Once a lone eighteenth-century village, Holmesburg is now engulfed by twentieth-century development sprawling across Northeast Philadelphia. The neighborhood named after William Penn's surveyor, Thomas Holme, thankfully retains a cluster of houses built in the early 1800s. One of them is the Griffith-Peale House, a beautifully proportioned, Federal-style residence, shown above. The house is particularly distinguished by the elegant detailing around the entry door and the two dormer windows.

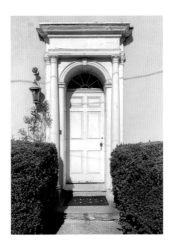

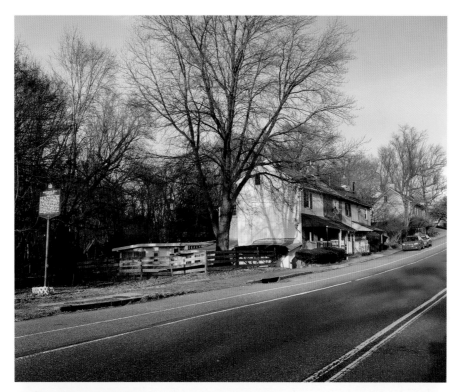

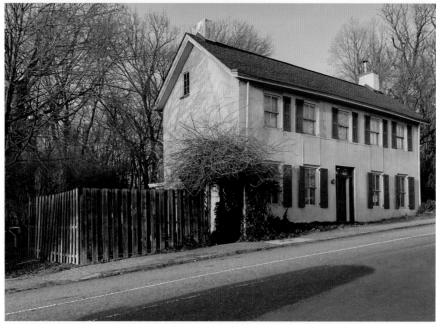

Whitaker Mills Houses, 5120–32 Tabor Road, Tacony Creek Park, Crescentville Neighborhood, Lower Northeast Philadelphia

On this busy stretch of Tabor Road traversing Tacony Creek Park, a motorist suddenly dips out of the densely structured city into a verdant valley outside of time. Along the roadway, one sees four picturesque rowhouses and a larger separate house. This is the former site of the Henry Whitaker Textile Mill, dating from 1813, which operated continuously for 157 years until 1970. The four rowhouses where the workers lived, and the large house belonging to the foreman, together form a vestige of Philadelphia's early industrial past.

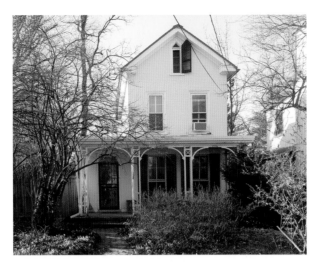

Penn Street, Penn Knox Neighborhood, Germantown, Northwest Philadelphia

The narrow width of the second floor, providing a vertical thrust, and the pointed window under the gable, tell us that this quaint cottage is in a version of the Gothic Revival style. The slender proportions of all the windows reinforce the Gothic effect. Emphasizing the vertical up-reach are the delicate wood supports of the porch roof. Built of extremely slender pairs of stick-like wood pieces, the supports are linked by graceful arches meeting at jewel-like decorative embracements.

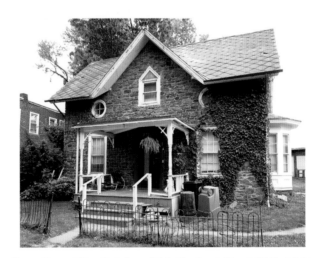

Green Lane, West Oak Lane Neighborhood, North Philadelphia

There is Green Lane in Manayunk, Green Street in Spring Garden, and Greene Street in Germantown, but this house is on *another* Green Lane. It is a one-block-long, quaint byway far up North Broad Street in West Oak Lane, a typical Philadelphia neighborhood spread over with acres of rowhouses. Built circa 1880, before the section was heavily developed, this charming stone cottage stands happily alone. The sloping roof breaks into a steeply sided gable under which a small pointed window signals that this is another example of the Gothic Revival style, though in a vernacular version. Note the two round windows, which add special character. Across the street, and enclosed by an ancient stone wall, is the historic De Benneville Cemetery, which, together with the house, make a visit to this other Green Lane worthwhile.

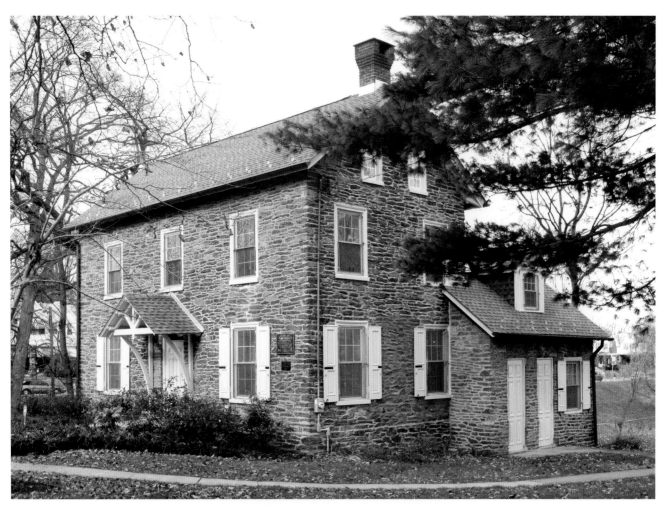

Sophia Chew Cottage, Musgrave Street, Mount Airy Neighborhood, Northwest Philadelphia

In the middle of the nineteenth century, unmarried Anne Sophia Penn Chew (1805-1892) was living alone in her great ancestral home, Cliveden, on Germantown Avenue when her nephew, Samuel Chew, requested that he bring his wife and six children into the mansion. Sophia assented to his request and then had built for herself this little farmhouse-like residence about four blocks east of the main house, on what were then the open fields of the Chew estate. Built circa 1884, the house has the aspect of a typical Pennsylvania stone rural dwelling, though with some Victorian touches, including the bracketed canopy over the front entry door, and pointed arched windows. It seems Sophia was most content to live out her years in her charming country cottage. It now belongs to the City of Philadelphia and is used as a community center for the surrounding Mount Airy neighborhood.

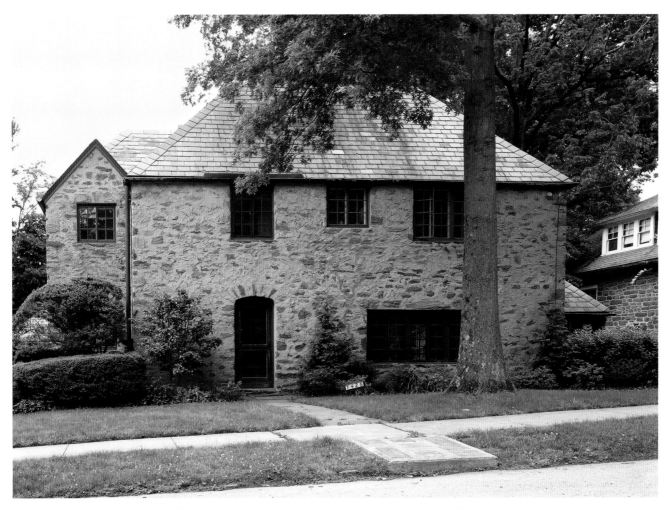

Ardleigh Street, East Mount Airy Neighborhood, Northwest Philadelphia

Striking in its simplicity, this house in the Norman Revival Style, built of Wissahickon schist stone smoothed over with mortar, is of a type commonly seen in the Northwestern neighborhoods of Mount Airy and Chestnut Hill. The absolutely flat front facade is penetrated without artifice by windows, placed wherever they need to be in relationship to the rooms behind. The one window aligned with the door anchors the composition. Set back from the front facade, the small gabled wing serves as a counterpoint to the dominant mass of the main body of the house.

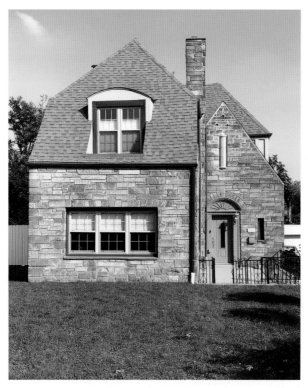

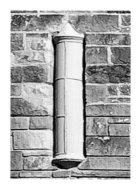

51st Street, Wynnefield Neighborhood, West Philadelphia

Emblematic feature over entry door thought to symbolize a Mezuzah

Wynnefield is one of several Philadelphia neighborhoods that have a cluster of detached, suburban-like single-family homes amidst extended rowhouse districts. Like East Falls across the Schuylkill River, it is amazingly close to the downtown, which can be reached in a few minutes on a route of green parkways. From 51st to 54th Streets, between City Avenue and Wynnefield Avenue, there are many fine large houses displaying a range of styles. The house pictured here is one of the most distinctive. Planned in an L-shaped form, it possesses a tall chimney that anchors the composition at the intersection of the two wings. Three distinct masses, each with steeply pitched roofs sloping in different directions, are adroitly fused together. With its tawny shingled roof, and stone facing with sections of stucco bordered by wood trim, the house is tinted pleasingly in shades of brown and tan. As shown in the oblique view below, the entry is set back adjacent to the chimney, felicitously affording entry to the center of the house. A small paved plaza, placed before the front door, offers a moment to pause and contemplate the outdoors before experiencing the interior.

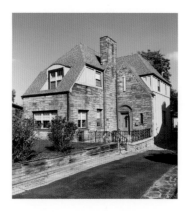

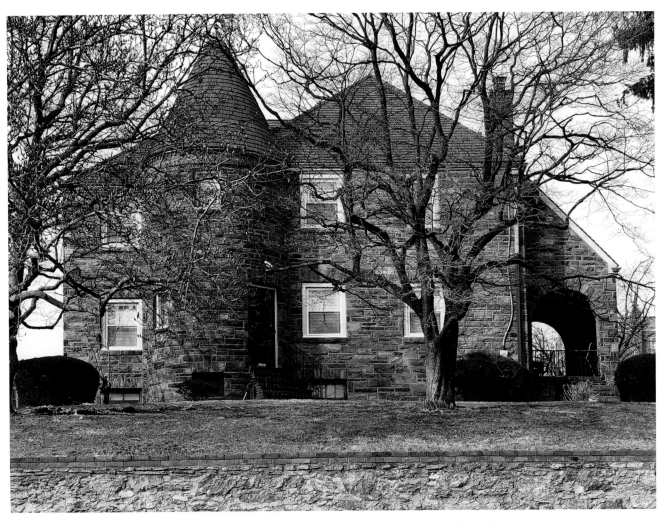

Callowhill Street, Haddington Neighborhood, Far West Philadelphia

This picturesque house is built in the Norman Revival Style, sometimes called French Provincial. The house lies right at the edge of Cobbs Creek Park near the western limits of the city. As a large detached house with ample yard space, it stands out among the otherwise tightly packed rowhouse blocks to the east. Sitting mysteriously alone, more like a house in the Chestnut Hill neighborhood, it makes one wonder why the original owners chose to build in this location. Buttressed by a stone retaining wall, the front yard is elevated above the street, lending the house a special presence. The asymmetrical massing of the house, with its off-center conical roofed turret, is balanced by the arched open porch.

Pine Street, Garden Court Neighborhood, West Philadelphia

This house is one of several detached single-family houses in the Garden Court neighborhood which was planned by visionary developer Clarence Siegel in the 1920s. Gathered into his plan as well are twins and high-rise apartment buildings. Seemingly inspired by the English Garden City movement of the early twentieth century, Garden Court is an example of enlightened, idealistic development, unfortunately uncommon in today's United States. The house shown was designed by architect John L. Coneys in a highly original, eclectic style, with echoes of the Arts and Crafts and Mediterranean Revival styles. Behind the house and those adjacent is a service lane—an innovative feature at the time—accessing private garages for the automobiles just then coming into more prevalent use.

Godfrey Avenue, East Oak Lane Neighborhood, Far North Philadelphia

The East Oak Lane neighborhood, at the furthest reach of North Philadelphia border-ing the Montgomery County line, is a big surprise. After traveling through miles and miles of streets filled with attached houses, both rows and twins, one comes upon a verdant, spacious, suburban-like neighborhood displaying detached houses on generous plots. There are houses of every style: Colonial, Queen Anne, Tudor, Norman Revival, and Modern. Many of these houses grace curving streets positioned off Philadelphia's insistent grid. Pictured is one of several houses in the Mediterranean Revival Style. The pale yellow stucco walls, the arched windows, and clay tile roofs—all are signifying features of this style. The house is given a commanding presence by the centrally positioned dormer-like element rising from the main body of the house, breaking through the roofline and penetrated by two small windows.

Dungan Road, Fox Chase Neighborhood, Lower Northeast Philadelphia

This quaint, well-kept, cottage-like house appears to be a design right out of the Sears Roebuck catalog. From 1908 until 1940, Sears sold these houses to buyers shipped in many parts with the blueprints included, to be constructed onsite. Though not stylistically innovative, they are pleasingly designed and offered their occupants a comfortable way of life at relatively low cost. The picket fence adds charm and what could be thought of as a front yard living room. Passing through it, one is greeted by the gabled roof of the entry vestibule swooping with a curve down near the ground.

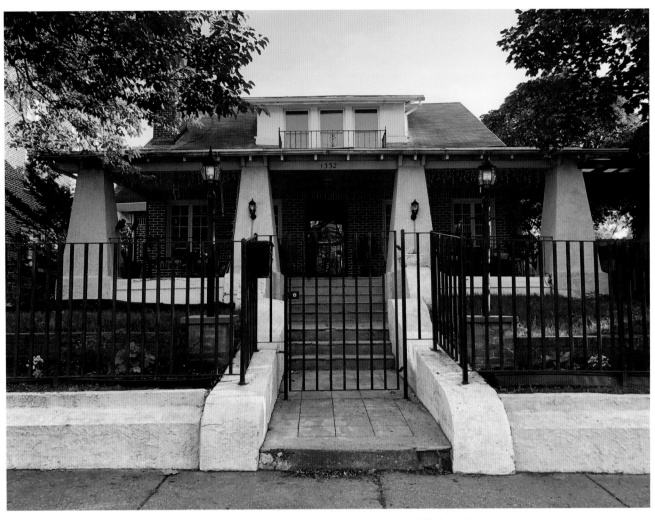

Arrot Street, Frankford Neighborhood, Northeast Philadelphia

Even with the enclosing iron fence and gate, the massive tapered porch columns of this bungalow seem to reach out along the sides of the front walkway, inviting passersby to enter the property. The Bungalow style is characterized by deep porches stretching across the frontage with gently pitched roofs sweeping back over one and a half stories penetrated by a broad dormer. The Bungalow style derives from prototypes seen in Bengal, India. They were popular and built all across the United States between 1905 and 1930, in older residential neighborhoods outside the denser city centers.

Herschel Street, Old Somerton Neighborhood, Far Northeast Philadelphia

Old Somerton, in the very northeast corner of Far Northeast Philadelphia, is twelve miles from Philadelphia's City Hall, but still within the city limits. As in Overbrook, about twenty miles away, its houses are set on spacious grounds and often on winding lanes. Here, a white-painted Colonial Revival house contrasts with the expansive carpet of green it rests on. Reflecting Pennsylvania tradition, there is a pent eave—a little half-sloped roof positioned just above the first floor. A pedimented canopy over the front door gently breaks into the pent eave.

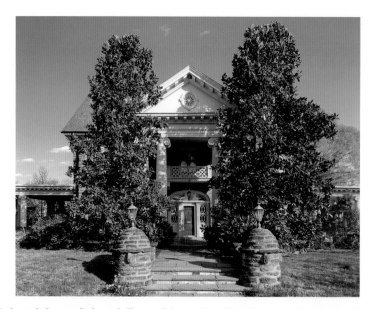

East Sedgwick Street, Sedgwick Farms, Mount Airy Neighborhood, Northwest Philadelphia

Sedgwick Farms was developed by Ashton S. Tourison Sr. early in the twentieth century on the east side of Germantown Avenue. This stately example of the Colonial Revival style, with its ionic columns and classical pediment, is among the large homes that fill the small neighborhood.

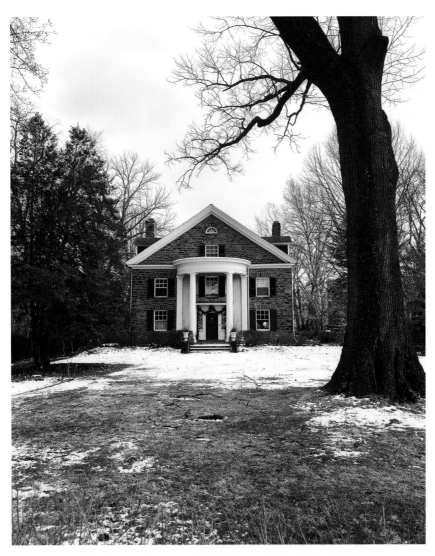

City Avenue, Overbrook Neighborhood, West Philadelphia

Sitting just on the Philadelphia side of the city's dividing line, in suburban-like Overbrook, is this house in the Georgian Revival style, asserting itself with a proud, half-round, columned portico crowned by an emphatic pediment. Unlike such houses situated farther south in the United States, this dwelling is built in Pennsylvania stone, rooting it in the architectural culture of the region. Even in a city packed tightly with dense, low-scale construction, there are houses set back on spacious front yards.

Mansions and Carriage Houses

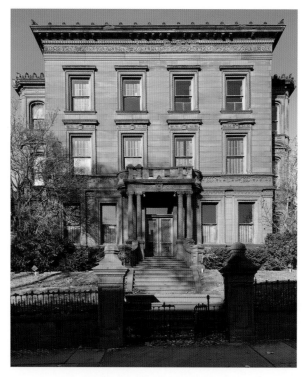

Green Street, Spring Garden Neighborhood, Center City Philadelphia

In general, Philadelphia homes range from small to moderate size. But here and there one can find very large houses—mansions—sometimes standing alone, and often included in rows. These are the abodes of the wealthy, both those who once inhabited them and in some cases those who still live in the city. Most of the mansions are creations of the eighteenth and nineteenth centuries, but there are a few built even in the twentieth. The homes of the affluent are a feature of every American city, and their presence in Philadelphia is no exception.

Americans have always emulated the rich. Residents and visitors alike relish seeing these big dwellings. They love to drive into the neighborhoods of the affluent and admire the extravagant habitations of people on an economic height to which they aspire. Naturally, tourists will want to visit such neighborhoods as Chestnut Hill or Society Hill. This book has pictured homes of the working class and the middle class, but this chapter will now focus on the homes built for the wealthy, which nevertheless take many forms and shapes.

Pictured is the brownstone Bergdoll Mansion on leafy Green Street, dominating the corner of 22nd Street in the Spring Garden neighborhood. It was designed in the Italian Renaissance style in 1886 by architect James Windrim (1840-1919), also the designer of Philadelphia's famed Masonic Temple. The house is essentially a large, chunky cube, albeit elegant in its restrained classical detailing. Relatively small wings project at the sides, relieving the massiveness of the main body of the mansion.

Often because of the immensity of these structures, they have been broken down into apartments, as was the Bergdoll Mansion, or turned to institutional and office uses. Some have not been well maintained, resulting in abandonment that poses a special challenge to their preservation. Yet their presence in the panoply of Philadelphia house types is of great value.

Inevitably, where nineteenth-century mansions are found, there will be accompanying carriage houses. Located on alleys and narrow back streets, they served as stables for horses and storage for carriages before the day of the automobile. These structures, though often removed from immediate view, are among some of Philadelphia's most interesting and charming. It seems that in many instances, the carriage houses provided their builders and architects opportunities for more vivid expression than was permitted to them at the main houses. Carriage houses often display exuberant and intricate masonry forms, unfamiliar compositions of windows and doors, and sometimes even artwork implanted in their walls. In many cases, the carriages have been separated off from the main house properties and converted into offices, residences, and artists' studios.

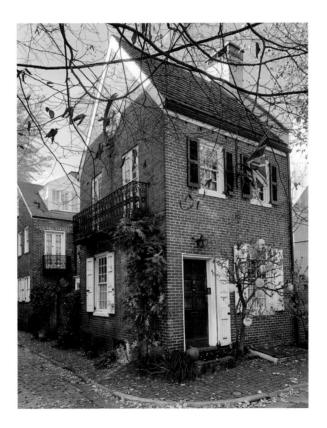

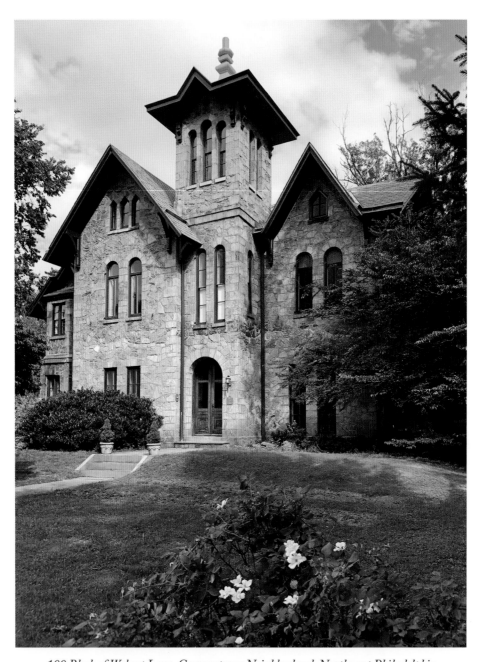

100 Block of Walnut Lane, Germantown Neighborhood, Northwest Philadelphia

This mansion attributed to architect Samuel Sloan (1815-1884), known as "Grey Tower," was built circa 1860 and altered 1912–16. In the alteration, porch fronts were removed, along with a considerable amount of fanciful wood trim, causing the rather austere yet imposing appearance of the present-day structure. Joseph Minardi, in his authoritative book, *Historic Architecture in Northwest Philadelphia*, writes: "The prominent feature of this stunning Italian Villa house is the dramatic central tower, an essential element of the style." Of historical note is that Grover Cleveland spent his honeymoon in the house and accepted his nomination for president while there.

Shelbourne Street, Lawncrest Neighborhood, Lower Northeast Philadelphia

Byberry Road, Somerton Neighborhood, Far Northeast Philadelphia

Both rather similar in style, these two mansions are located in Northeast Philadelphia, but given the immense expanse of that part of the city, they are located miles apart. Sitting on generous, verdant plots, both are in variations of the Queen Ann style, but unlike the brick mansions in Center City, they are of wood construction enabling more sculptural expression. Both display an assortment of gables and dormers sprouting from the mass of the dwelling. Both have rounded corners and porches serving as entries. Wood shingles and siding of different designs sheath their exteriors. Though not the biggest or most luxuriant of such mansions, the two exemplify homes of wealthy Philadelphians who with the provision of Philadelphia's expanding transportation infrastructure in the late 19th and early 20th centuries, moved out to the far reaches of the city to find a more suburban way of life.

Loudoun Mansion, Germantown Avenue and Abbotsford Road, Germantown Neighborhood, Northwest Philadelphia

The historian John Francis Marion wrote in his extraordinary book, *Bicentennial City*, that " Loudoun is one of the glories of Germantown and Philadelphia." As a rule, this book shows only lesser-known examples of residential architecture in Philadelphia. Loudon is included here because, despite its prominent location high atop Neglee's Hill, it is less well known to the public. Built about 1801 by Thomas Armat, with the Greek Revival portico added in 1830, the mansion is now owned by the City of Philadelphia. A damaging fire in 1993 limited its accessibility. With greater renown, perhaps the interior of the house will one day be restored to its former magnificence for all to see.

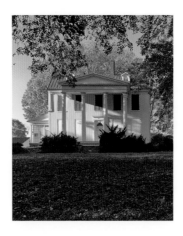

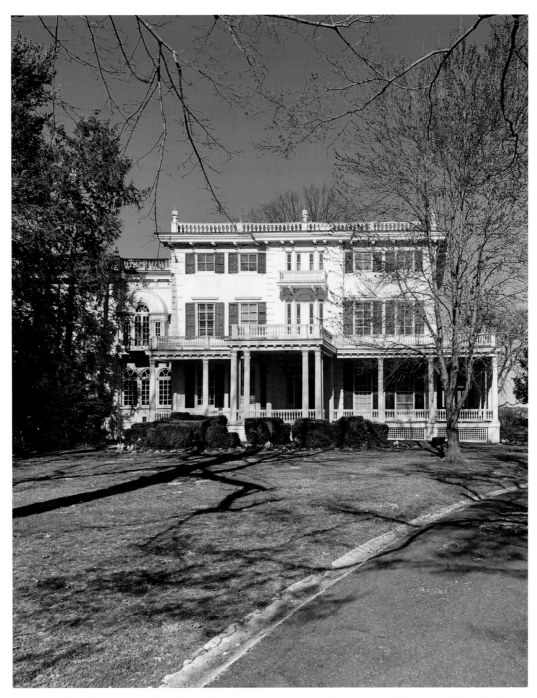

Glen Foerd Mansion, 5001 Grant Avenue, Torresdale Neighborhood, Far Northeast Philadelphia

Glen Foerd overlooks the Delaware River near the mouth of Poquessing Creek. It was built as a summer house in 1850 by banker Charles Macalester Jr. In 1893 US Congressman Robert H. Foerderer purchased it, enlarging it into an Edwardian Classical Revival style mansion. Acquired by the City of Philadelphia in 1985, it now serves as a house museum and public park. Although within the boundaries of the city, the mansion and grounds will transport the visitor to an unsuspected world, remote in atmosphere from the surrounding metropolis.

19th Street, Rittenhouse Square Neighborhood, Center City Philadelphia

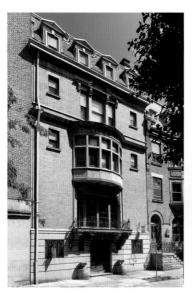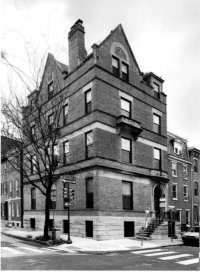

Town Mansions, Locust Street, Rittenhouse Square Neighborhood, Center City Philadelphia

At the turn of the nineteenth and twentieth centuries, many wealthy Philadelphia families settled around Rittenhouse Square. Adorning the surrounding streets, handsome mansions were built to accommodate this affluent class. These large residences were often built in the Georgian Revival and Renaissance Revival styles, which were well suited, by virtue of their relative simplicity and flat facades, to be fitted into mid-block locations or attached to corner sites, providing the streetscape with an urban and urbane appearance that their owners desired.

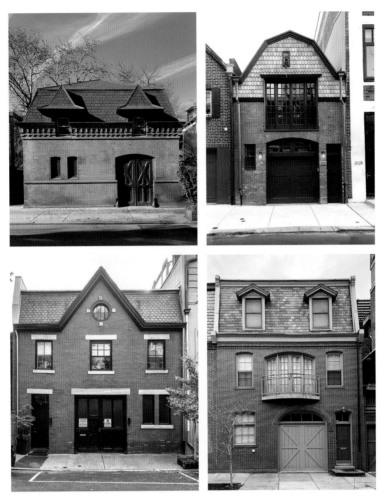

Carriage Houses, Rittenhouse Square Neighborhood, Center City Philadelphia

Many of the carriage houses have been converted into dwellings for people who like to live in the narrow, quiet back streets and alleys that abound in Center City. In these examples, the carriage house architects seem to have had a freer hand in their design and have generated quite inventive facades. Modest in scale, these structures offer some of the city's most fascinating architecture.

Carriage House Society Hill Neighborhood

Unusual Houses

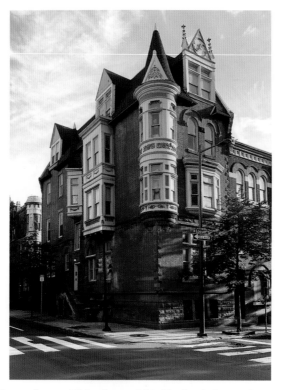

23rd and Spruce Streets, Fitler Square Neighborhood, Center City Philadelphia

With Philadelphia's invariable regularity, the city's spice and spunk often derive from the occasional unusual or even eccentric house—the architectural outburst of some daring owner, builder, or architect. Roving through the city, the inveterate Philadelphian who has been accustomed to its endless stretches of rowhouses is startled to encounter a somewhat aberrant construction, be it in the Victorian style or in the modern mode. It is a stimulating experience, like encountering a deer crossing a city street, which does in fact happen in Philadelphia.

The house shown above leading this chapter is in the Queen Anne style, pushed to the very limits of its possibilities with four types of projecting bays, including the two-story corner turret raised dramatically above the sidewalk. On the Spruce Street frontage, an oversized dormer projects from the attic, giving the appearance that it is taller than its actual four stories. The house was built for Dr. Joseph S. Neff in 1894, and the architect was Charles Balderston (1852–1924).

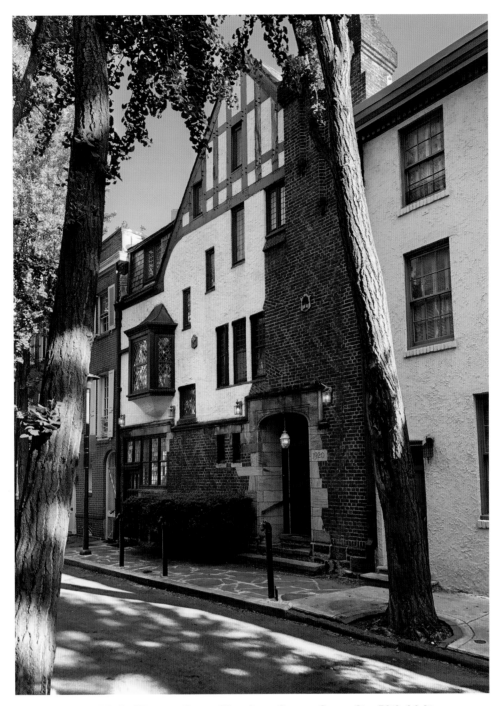

1900 Block of Panama Street, Rittenhouse Square, Center City Philadelphia

Every neighborhood, no matter how modest or plain, has a few of these unusual constructions. Of course, the perception of the unusual is contextual. What might seem normal in one neighborhood would be entirely exceptional in another. For example, seeing a twenty-five-foot wide Tudor house set down in a stretch of sixteen-foot wide rowhouses, as on the 1900 block of Panama Street in Center City, would be an unusual sight, one much out of the ordinary. The occasional "out of place" house set down in an otherwise regular neighborhood may paradoxically provide a sense of comfort to the visitor, as a reminder of the reality of a wider world beyond.

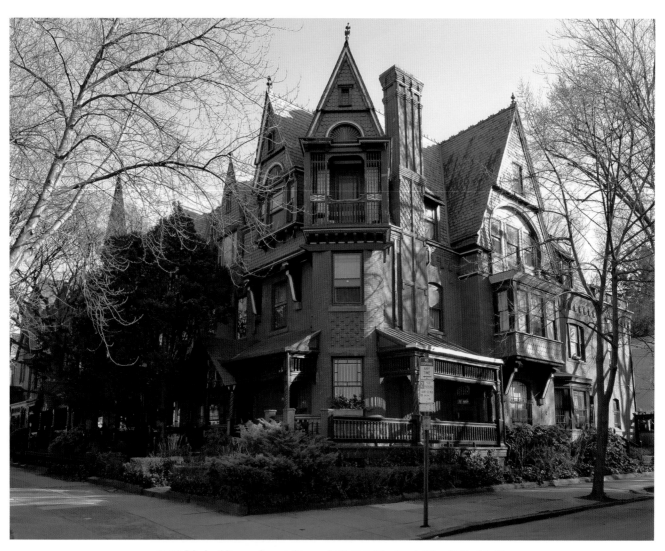

4200 Block of Spruce Street, Spruce Hill Neighborhood, West Philadelphia

At the western end of a row of seven dwellings designed as a single, unified composition, the house shown above turns the corner down narrow St. Marks Place. The picturesque ensemble was designed in 1889 by the famous G.W and W.D. Hewitt Brothers firm (1878–1907). Here, a profusion of large and small gables, some of them topping balconies, are pleasingly jammed together; stretches of porches, unusual decorative features, and varied but tasteful combinations of materials, all artfully fuse to create a distinguished piece of architecture. It is perhaps the most original example of the Queen Anne style in Philadelphia.

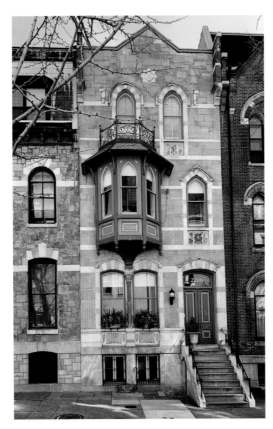

Saint James Place, Fitler Square Neighborhood, Center City Philadelphia

The 2200 block of Saint James Place is richly endowed with fascinating architecture, perhaps more so than any block in Center City. There are houses attributed to Frank Furness, Wilson Eyre, and an assortment of other distinguished Philadelphia architects. The house shown here is by architect Lindley Johnson, in a very personal and original version of the Gothic Revival style. The canopied oriel window is supported by unusually ornate brackets and topped by a fanciful railing. The closely spaced windows of this house and others on the block suggest the architecture of Venice and the influence of John Ruskin, proponent of Gothic architecture. Immediately to the west is a row of houses by Wilson Eyre, continuing the Venetian theme with the closely spaced, pointed arched windows. Walking into this block, one is transported into the ambiance of the wealthy elite of the late nineteenth century.

Ornament on house attributed to Frank Furness on same block.

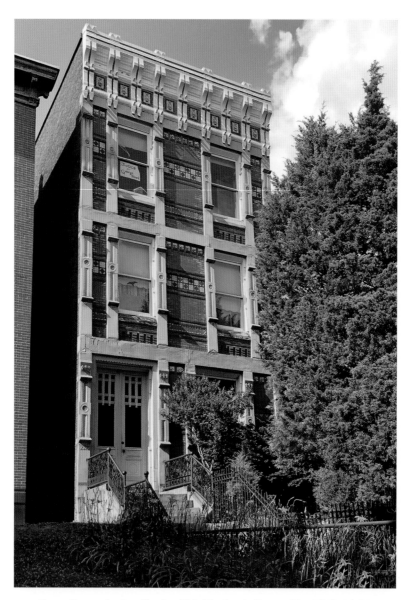

Green Street, Spring Garden Neighborhood, Center City Philadelphia

Rising high above one of Philadelphia's most beautiful streets, this house, designed by architect Willis Hale (1848–1907) for clothing manufacturer Morris Fleisher, is utterly unique. Compare it to the prototypical Philadelphia rowhouse shown next door in the photo, and this becomes clear. In a style of its own but with Queen Anne and Charles Eastlake traces, its polychromatic facade is banded vertically and horizontally by slightly raised stone pilasters establishing placement for the doors and windows, and defining the outer edges of the frontage. Rows of decorative tiles of encaustic and terra cotta, placed at different levels, enliven the brick expanses. The cornice has two tiers: the higher, made of intricately crafted wood brackets or modillions; the lower, a frieze built of tiles in a pattern that visually supports the design above. The latticework of wood strips in the glass panels of the double-entry door reflects the design of the cornice.

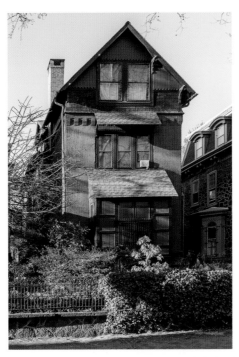

Baring Street, Powelton Village, West Philadelphia

Among the many porch-fronted, mansard-roofed Victorian houses of Powelton Village, this house, bereft of those features, stands out. No wonder, as it is the work of the famous architect Frank Furness (1839–1912), known for his very original if not idiosyncratic design. Samuel Shipley, president of the Provident Life & Trust Company, commissioned Furness in 1883 to design the house as a gift to his daughter Anna upon her marriage to Samuel Troth. The house is unusually narrow, as is demanded by the site, giving the three-story structure a vertical thrust. Wood siding standing upright fills the space under the gable, reinforcing the vertical effect. Wood appears again at the first-floor bay in a paneled configuration. The overhanging gable, and sloping overhangs at the first and second floor, shield the windows facing the sun in the southern sky.

Van Pelt Street, Rittenhouse Square Neighborhood, Center City Philadelphia

On a narrow back street, here is another house by Frank Furness, uncharacteristic in its modesty and simplicity.

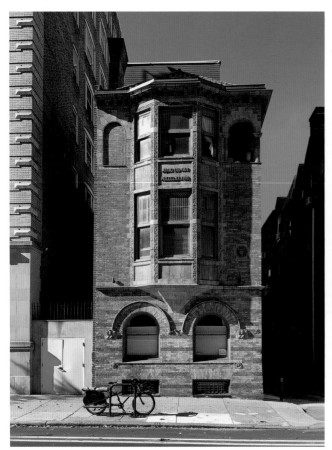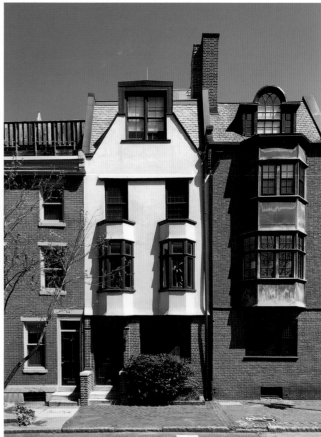

Left: 22nd Street, Fitler Square Neighborhood, Center City Philadelphia;
Right: Locust Street, Rittenhouse Square Neighborhood, Center City Philadelphia (right)

These two houses are the work of Philadelphia architect Wilson Eyre (1858–1944). Working in the late nineteenth century, Eyre is not as well-known as the somewhat older Frank Furness, but perhaps he deserves as much recognition. Eyre's houses, many of which are scattered around the Rittenhouse Square neighborhood, are particularly innovative in their design. Despite their structural rigor, they succeed in achieving a picturesque quality. Eyre grew up in Florence, Italy, and perhaps his early exposure to the architectural traditions of that city served as an inspiration for his work to come. Notice the corner balcony on the third floor of the 22nd Street house, a romantic feature suggesting a scene out of a certain Shakespearean play. Paul Hogarth states in his book, *Walking Tours of Old Philadelphia*, that Eyre was typically Victorian in that he "borrowed from every country and from every period, and blended them together with extraordinary skill." The scantly adorned Locust Street house demonstrates another distinctive approach, with its abstract, almost modern feature consisting of the very geometric dormer that splits the gabled roof in two.

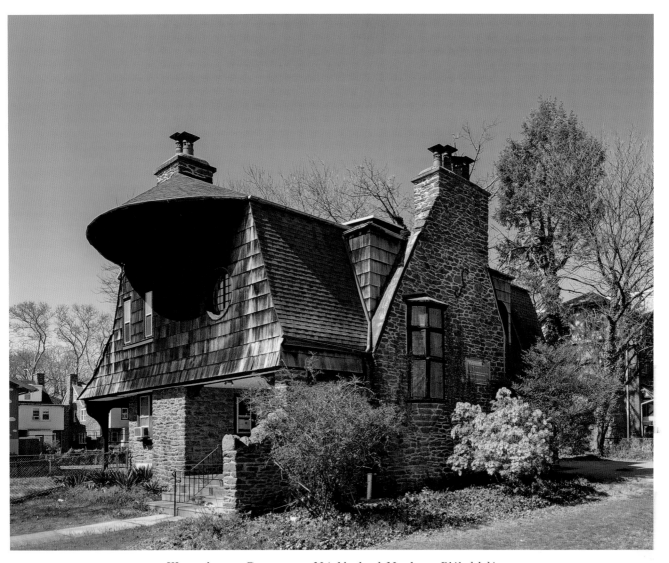

Wayne Avenue, Germantown Neighborhood, Northwest Philadelphia

This unusual house is now owned by distinguished Philadelphia historian and preservationist, Oscar Beisert. Beisert tells us that "Miss Sarah 'Sallie' R. Watson, always a single woman, commissioned in 1886 a young Wilson Eyre, the architect, to design this Arts & Crafts/Shingle Style cottage." Ms. Watson lived there for 30 years until 1906; Beisert is the first owner/occupant of the house since then. Note that the expanses of shingle siding are combined with considerable stretches of handsome Wissahickon schist stone. This relates the house to its Northwest Philadelphia context, where such stonework is abundant. To fully appreciate the house, one must consider it as if it were a sculpture, to circulate around and view from every vantage point. This is because each facade explodes with fascinating sculptural forms that the viewer would miss standing directly in front in any one frontage.

East Coulter Street, East Germantown Neighborhood, Northwest Philadelphia

Set back from the street, this charming Victorian cottage has a two-story masonry section capped by an overhanging gable on one side, with an open porch entryway on the other. The resultant asymmetry is resolved by the adroit play of solid and void. The gridded, triangular screen over the porch is an unusual feature, and the decorative element at the peak of the gable is another inventive touch. The mix of stone, brick, and wood, topped by fish-scale siding, displays the skill of the anonymous designer. The architectural scene, supported visually by the stone retaining wall lining the sidewalk, delights the passerby.

Warden Drive at Vaux Street, East Falls Neighborhood, Northwest Philadelphia

With its undulating roof and the eaves taking the form of eyebrows over the windows, this house clearly fits into the unusual category. The house appears to be an interpretation of an English thatched-roof rural cottage set down in the American suburban-like environment of East Falls. The half-timbering in the forward-stepping mass gives the house a Tudor resonance. Note the eyebrow over the vent opening, exactly centered over the dip in the eave below. The architect of the house is unknown, but it seems the developer was Michael McCrudder, who in the 1920s built most of the houses along winding Warden Drive (see page 45) and in the Tudor East Falls Historic District.

Bainbridge Street between 2nd and Front Street, Queen Village Neighborhood, Center City Philadelphia

Wooden houses are very rarely seen in Philadelphia. Early in the city's history, fire-prevention laws were passed requiring brick construction. Nonetheless, a few survive in Queen Village, one of Philadelphia's oldest neighborhoods. Among the wooden survivors, this one is unique, standing detached from adjacent construction, allowing views of the wooden clapboard applied to its side walls. Neat and prim, almost like a piece of antique furniture, the wooden house startles the passerby amidst its neighboring red-brick rowhouses.

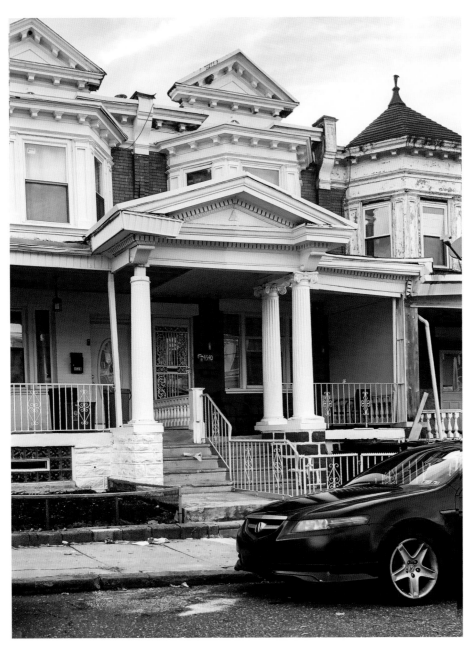

North 13th Street, Logan Neighborhood, North Philadelphia

Here, the classical architectural elements of an Italian villa are tightly stacked, one on top of the other, on the front of an otherwise modest row home. A projecting, pedimented canopy supported by Ionic columns shelters the entry stair; then an open porch steps out, topped by a bay window at the second floor. Finally, all is capped by a broken cornice from which another small, purely decorative pediment emerges, crowning the composition. A striking display of light and shadow is thereby created. One must herald the developer-builder who invested so much effort in creating this richly conceived facade. But one must lament the condition of this low-income neighborhood where it is a considerable challenge for owners to maintain such intricately detailed wood frontages. Notice the leaning post that temporarily takes the place of one of the four columns.

South Lawrence Street, Queen Village Neighborhood, South Center City Philadelphia

This house is without known precedent in Philadelphia's array of dwellings. Multi-paned windows and paneled doors, drawn with elegant, attenuated proportions, dominate the facade. The industrial-style windows reveal the dwelling's origins as a former workshop building. While it fronts Weccacoe Playground on the east, the property continues through to 5th Street on its west side, where the formal entry is located. Quiet, tree-canopied Lawrence Street, shown above, offers no on-street parking, thus allowing the children an almost private extension of the adjoining playground. The projecting wrought-iron balcony stretching across the house frontage affords an opportunity to view the lively open space from above. As a point of history, Weccacoe Playground includes a section that served as the first African-American private cemetery in Philadelphia. A historical plaque placed in the cemetery area of the playground marks the site's significance.

Weccacoe Playground

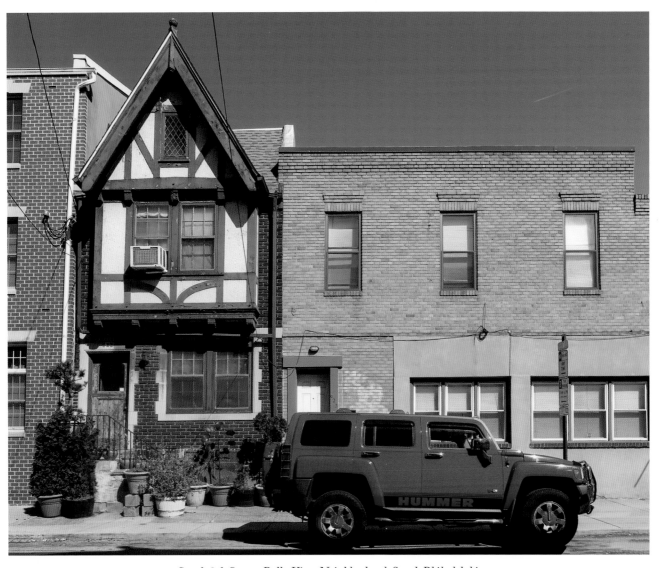

South 8th Street, Bella Vista Neighborhood, South Philadelphia

In another context, this half-timbered house in the Tudor style would not be so unusual. But amidst the South Philadelphia neighborhood of rowhouses and commercial buildings, it is a singular object. Narrowly proportioned, it appears no wider than the red Hummer. The brick and stone ground floor is overhung by the half-timbered second floor, and again overhung by the attic, capped by an over-reaching gable. The house is a well-crafted period piece.

Waverly Street, Fitler Square Neighborhood, Center City Philadelphia

In 1967, architect Anne Tyng (1920-2011) took an ordinary, vernacular two-story rowhouse and turned it into a small but exquisite home of her own. After gutting the inside, she remodeled the interior, added a third floor, and changed the proportion of the windows in the front facade. The third-floor addition shows her penchant for geometric configurations yielding the angular forms of the roofline. The entry door is in the middle of the house, accessed by a narrow side alleyway. Anne Tyng was a professional associate of architect Louis I. Kahn (1901–1974), and with her interest in geometric forms, was an important influence upon him. The Waverly Street house is known to architects throughout the world, but is not as familiar to Philadelphians as it should be.

Carlisle Street, Packer Park Neighborhood, South Philadelphia

This house must certainly be the most fantastical dwelling in the entire city. Inserted between two of the architecturally bland houses of Packer Park, the eccentric abode represents the imagination of an owner seemingly richly endowed with an inner life of memories and visions. The angled staircase leading to the ornately canopied entryway, topped with winged goblins taking flight, is spectacular. What might the creatures symbolize to the owner? The stone parapet of the balcony, anchored at either end with statuary, and the gabled roof above it, penetrated with tiny arches, do not disappoint.

Modern Houses and the New Vernacular

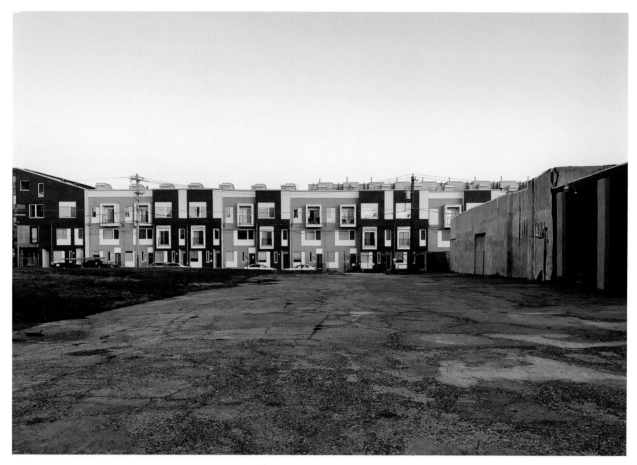

Randolph Street, West Kensington Neighborhood, North Philadelphia

The Modern

I n the suburbs reaching out beyond Philadelphia, there are plentiful examples of houses built in the modern architectural styles of the twentieth century and the early twenty-first. But within the boundaries of the actual city, there are relatively few such houses. Those examples of modern architecture to be found in Philadelphia, and for that matter throughout the United States, break down into two general types. One is a cubistic, vertical approach with its origin in European artistic movements, particularly the Bauhaus School architecture of the 1920s. The other is an organic, purely American strain influenced by the more horizontal, earth-bound architecture of Frank Lloyd Wright. In searching the city, a few examples of both trends can be discovered. The cubistic, vertical structures are generally to be found in the older, denser sections of the city, simply because the building sites are smaller, requiring that houses reach farther into the sky to provide room for their occupants. In the more suburban sections on the edge of the city, such as East Oak Lane or Somerton, with more land to build on, horizontal house types are more typical.

The New Vernacular

With exceptions, most of the rowhouses, twins, and courtyard houses that are seen throughout the city fit into what is commonly called the vernacular. As applied to architecture, the term vernacular has a somewhat fluid meaning, but in general, it refers to buildings constructed by developers, contractors and tradesmen, for the most part without the specific involvement of professional architects. Readily available materials and familiar architectural motifs employed together reflect the traditions of the everyday people in the particular locale. It is a style, one could say, without a style.

If you look at a vernacular Philadelphia rowhouse built in the eighteenth and early nineteenth century, you will most likely see a flat-fronted building constructed in varying shades of red brick. It would stand two or three stories high, about sixteen feet wide, with two double-hung windows on the upper floors and a door with one or two windows on the first floor. A cornice of more or less simple design would cap it off at the roofline. Toward the end of the nineteenth century, a porch on the ground floor and angled bays were often added. In neighborhoods more distant from the city center, stone appears as a material for these vernacular houses.

In the twenty-first century, starting about 2010, a new vernacular began to emerge. Instead of brick, metal or cement panels cover the exteriors, displaying varying compositions and color patterns. Some of these houses have small sections of wood siding in a natural finish. Bigger windows with larger expanses of glass are another feature. Projecting from the upper floors are panel-covered bays with right-angled corners, sometimes called "box bays." To a considerable extent, the prefabricated panels have taken the place of brick in the everyday residential architecture of the city. Streetscapes deep in South Philadelphia and to the north and west of Center City are assuming a new look, after being filled for over two centuries by houses built of red brick.

Why has this happened? There are a variety of reasons. One is simply the lower cost of attaching metal panels to the exteriors, compared to the labor-intensive and costly process of laying bricks one by one. And the relatively large metal panels cost less than the equivalent number of bricks filling out the same area. From a functional standpoint, the projecting right-angled bays provide a little more space on the upper floors in otherwise smallish rowhouses. Bigger windows with large expanses of glass allow for better-illuminated interiors and more compelling views of the surroundings. It is not only cost and function; there is also the consideration of taste. Young people moving into the city seem to feel that the traditional rowhouse clad in red brick is just too old-fashioned. They are the ones generally purchasing these new dwellings, and they like what they believe is a more modern look. The multi-colored panels applied in varying patterns, the brick, in tan or gray colors instead of red, the large windows, all seem to fit their taste.

Unfortunately, older traditional houses are being demolished to make room for the houses built in this new vernacular. And these houses are springing up like patches of mushrooms in Point Breeze, Fishtown, Francisville, and other similar neighborhoods. The complexion of the city is changing. The city's earth-toned, red-brick skin is peeling away. Blocks that were once harmonious in their regularity, now display a motley array of dwellings discordant in their aggregation.

As an exception, the lead image for this chapter shows a long row of houses in the New Vernacular style with a more coherent design. Seen in long view beyond the expanse of a vacant industrial site, they have their own visual appeal, even while departing completely from the traditional Philadelphia rowhouse aesthetic. Open balconies are inserted into projecting box-like frames. A varied palette of white, tan, and brown colors dances across the length of the row, stimulating the senses. A new Philadelphia streetscape is proposed. Will future generations of Philadelphia home-dwellers readily adopt this unprecedented way of building their city?

As in any approach to building, there are better and worse examples. Here and there one finds individual houses, and rows as those shown in the Randolph Street photograph above, that are artfully designed in the New Vernacular style. Even though these houses fall into the vernacular category, the skills of a professional architect can sometimes be discerned. These dwellings demonstrate agreed-upon standards of good architecture: pleasing proportions, balanced massing whether symmetrical or asymmetrical, restraint and harmony in the selection of materials and color, considered relationship of detail to total form, and appropriate connection to context. Hopefully, these few successes will set an example for future construction. In either event, architectural styles change as they always have over the centuries, and to stand in the way of these transformations is utterly futile. As much as we might try to resist, history inexorably unfolds.

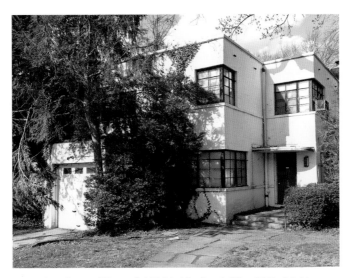

51st Street, Wynnefield Neighborhood, West Philadelphia

Built in 1935, this house is the work of architect Norman Rice (1903–1985), a classmate and friend of Louis Kahn. With its simple cubist form rendered in white plaster, its flat roof, and corner windows, it serves as an excellent example of the pure Bauhaus style (also called the International style)—rarely seen at that time in Philadelphia, but then in vogue in Europe. The canopied entryway is located in a set-back extension, providing plasticity to the massing and an advantageous entry to the dwelling.

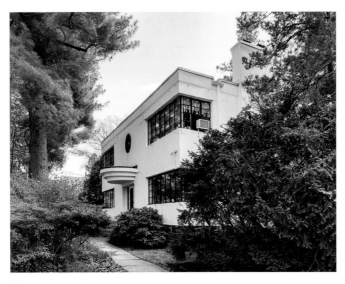

Murdoch Street, Mount Airy Neighborhood, Northwest Philadelphia

Here is another Bauhaus-style house with its corner windows; however, it has touches of the Moderne style with the added features of a stepped canopy over the entry door, the round window above, and the continuous molding below the roofline. Moderne was a more decorative version of the Bauhaus style popular in the 1920s and 30s, particularly in France and the United States.

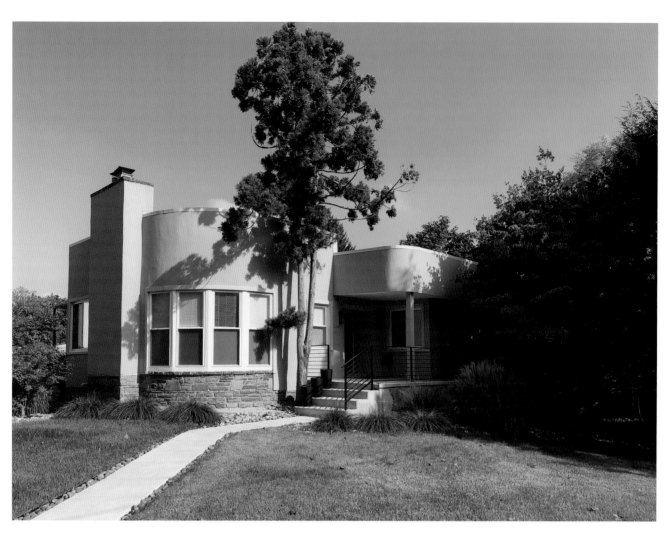

51st Street, Wynnefield Neighborhood, West Philadelphia

This house is in the early twentieth-century European Modern style but differs from the typical model with its display of two sensuous curved masses. With its bare stuccoed walls, flat roofs, and windows wrapping around the front round corner, the house is in a variant of the Bauhaus style. What would not be typical of the style is the stone base, firmly meeting the ground, which relates the structure to its Pennsylvania context. The lower rear mass has an open overhang signaling the entryway from the street while protecting the visitor from the elements at the doorway. The prominent chimney is an important element in the sculptural play of forms.

24th Street, Fitler Square Neighborhood, Center City Philadelphia

This house was built in the early 1960s when very few modern houses were located in the historical center of Philadelphia. Though built of yellow Roman brick, its form resembles the white-stuccoed, cubistic architecture of the Bauhaus style. The entry is through a gate leading to an open courtyard. The dwelling, wrapping around the courtyard on three sides, is a variant of the atrium house typical of Roman domestic architecture. In relation to the total mass of the structure, the garage is unobtrusive and serves to provide a terrace above, entered from the second floor of the house.

American Street, Northern Liberties, Lower Northeast Philadelphia

This is the home of well-known photographers, Ray Metzger (1931-2014) and his wife Ruth Thorne-Thomsen. Designed by architect Walter Molesky (1936-2019), it evokes in its simplicity, cubistic forms, and tan stucco finish the architecture of the American Southwest that the inhabitants loved to visit. The second-story section facing the street serves as the photographic studio. Visible through the open gate at the carport entry is an additional, separate structure, serving as the living quarters, and surrounded by an expansive garden space. Note that the parapet at the roofline steps down from the studio portion to the gate, providing a pleasing transition from high to low.

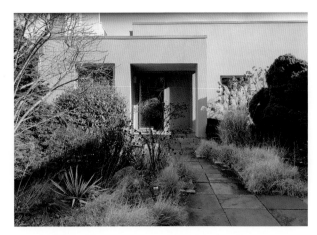

View from the gate to the living quarters.

Cherry Lane, East Falls Neighborhood, Northwest Philadelphia

One of several in the Philadelphia area designed by famed architect Richard Neutra (1892–1970), this house was built in 1958 for artist Kenneth Hassrick on the edge of Fairmount Park. Neutra was born in Vienna and migrated in 1923 to the United States, where he worked for a time with Frank Lloyd Wright. His architecture is a skilled amalgam of the undecorated, abstract style advocated by Austrian architect Adolph Loos (1870–1933), with whom Neutra studied, together with Wright's organic, horizontal Prairie style characterized by uniting the house interior with the great outdoors. The house, purchased by Thomas Jefferson University, has been integrated into their East Falls campus.

Oak Lane, East Oak Lane Neighborhood, Far North Philadelphia

These houses in two suburban-like neighborhoods are still within the city limits, but about ten miles distant from one another. They are in what has come to be called the Mid-Century Modern style. Built in the 1950s–1960s, the houses were then called ranch houses because of their low-slung, earth-hugging profiles. Middle-class Americans in that era preferred one-floor plans with a minimum of stairs. These two houses show the influence of Frank Lloyd Wright's Prairie Houses with their horizontal emphasis, including pronounced roof overhangs that protect the interiors from the penetrating south sun. The use of naturally finished wood siding and stone also reflects the influence of Wright's architectural style.

Proctor Road, Somerton Neighborhood, Far Northeast Philadelphia

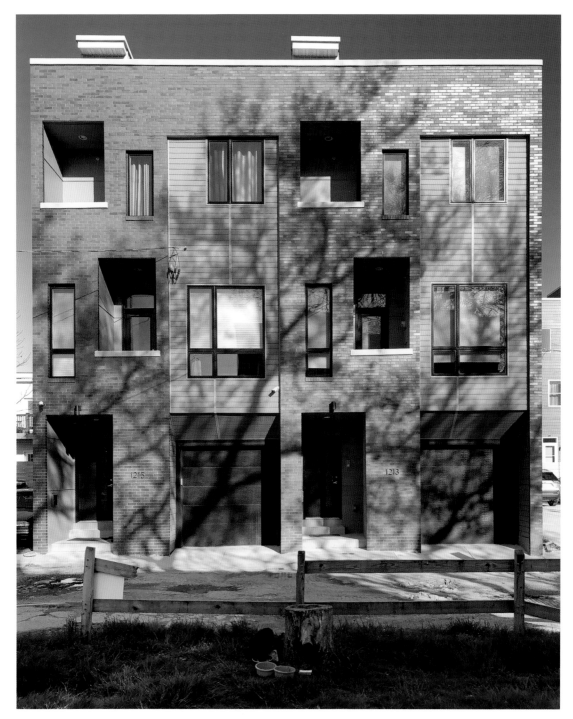

Pennock Street near 2700 Block of Stiles, Brewerytown Neighborhood, North Philadelphia

These twin houses, hidden away on a back street, are among the best in design to be found in the New Vernacular style. The dancing rhythms of the windows and the shadowy, recessed balconies and doorways are most appealing. The gray brick and russet-colored siding pleasingly complement each other. The garage doors set back in darkness are almost unnoticeable.

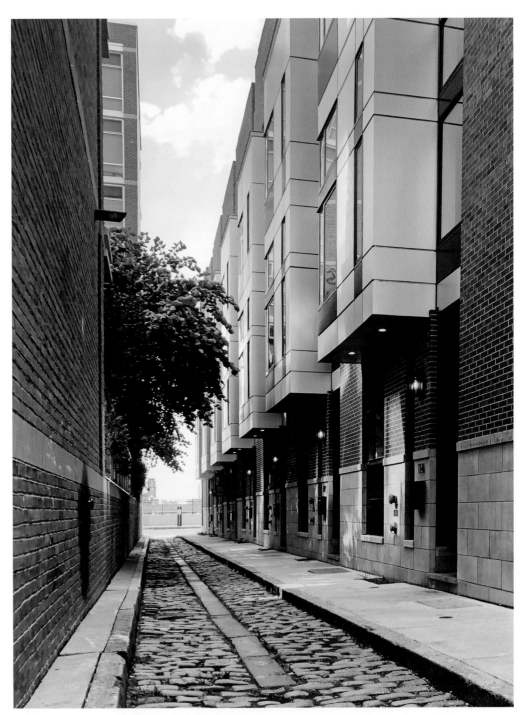

Black Horse Alley, Old City, Center City Philadelphia

Black Horse Alley is a narrow, antique cartway paved in Belgian blocks, divided by long stone strips. Evocative in its own way, it is one of Philadelphia's oldest surviving streets in one of its oldest neighborhoods, but now lined with rowhouses recently built in the New Vernacular style. The original eighteenth-century inhabitants of the street would be shocked to return and find these structures, with their assertively projecting, metal-paneled box bays, standing on the now-historic street they strolled along so many years ago.

Seybert Street, Temple Town Neighborhood, North Philadelphia

Scores of new houses on the periphery of original Philadelphia take the form of this house with its two-story, metal-paneled box bays and brick cladding at the ground floor reaching up to either side of the bay. The pattern of the black and silver panels on the bay is striking. One wonders if the jazzy composition is the conscious work of a professional designer or if it just represents a random placement by the workers installing the panels. Regardless, here is a new aesthetic raging across neighborhoods of the city, altering their accustomed appearance.

Aspen and 22nd Streets, Fairmount Neighborhood, Center City Philadelphia

Here, a house in the New Vernacular style is molded into a tower firmly anchoring the corner site. Red brick frames the angled, gray metal-paneled bays, relating the house to the pervasive red brick typical of the surrounding neighborhood. Blank garage doors fronting the street are now frowned upon, but the considerable height of the narrow three stories above distracts a disapproving eye from the one in this house. Orange-colored posts that support the overhanging floor rest on a stone base, serving as a planter straddling the sidewalk.

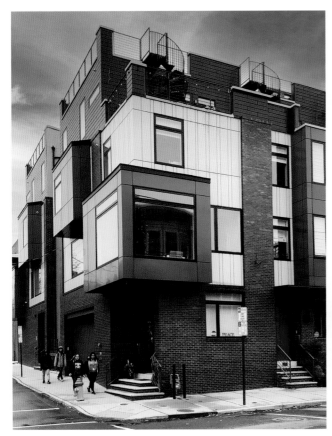 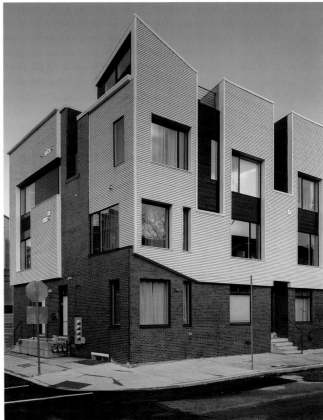

Fairmount Avenue, East Poplar Neighborhood, North Philadelphia

Like the Kensington, Fishtown, and Northern Liberties neighborhoods, the Poplar neighborhood has seen an explosion of new construction in recent years. These neighborhoods have not been designated official historic districts; a historic designation would have regulated changes to existing houses and the design of new houses. This lack of rules has resulted in a free-ranging approach by architects and builders, altering the formerly more homogenous character of the areas with their rows of historic two- and three-story red brick houses. Now there is an inharmonious spectrum of house styles in evidence—some might call it architectural anarchy. Although they depart radically from the architectural traditions of the area, the two houses shown here display an exuberant sculptural approach and are among the best to be seen in the vicinity.

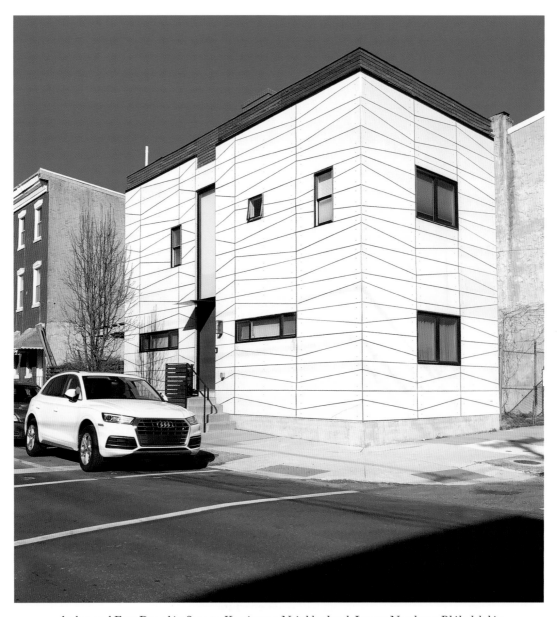

Amber and East Dauphin Streets, Kensington Neighborhood, Lower Northeast Philadelphia

In the evolving working-class neighborhood of Kensington, the younger new population has created some of the most inventive architecture to be seen anywhere in the city to Kensington Without the regulations a historic district provides, a degree of architectural freedom is offered to designers. Many of the houses are variations of the New Vernacular style with its projecting box bays and multi-colored metal panels. This house is different, showing attributes of the Bauhaus style with its cubical simplicity, its sheer white walls (albeit constructed of metal panels rather than plaster), and its studied placement of the windows and door. Those thin sloping lines drawn on each of the panels add an unprecedented feature, giving the house a zippy vitality that hopefully will inspire more innovation in the neighborhood's future architecture.

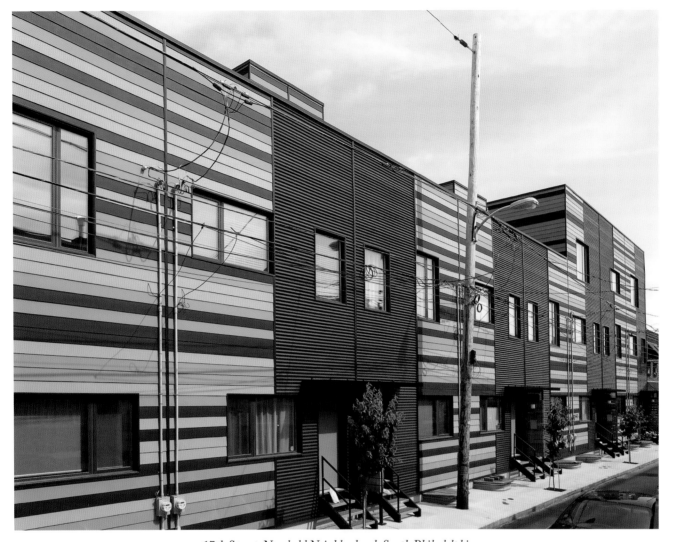

17th Street, Newbold Neighborhood, South Philadelphia

Designed by Interface Studio Architects, ISA, in 2017, these houses in the New Vernacular style probably represent the most extreme departure from the traditional Philadelphia red brick rowhouse. In fact, there are no masonry materials of any type used in the construction here—the exterior surfaces are made up of all-metal panels of different dimensions and textures. The thin, stripe-like, horizontal colored panels, in a palette ranging from light blue to gray, emphasize the directionality of the narrow one-way street. Modern-type windows, with their large expanses of glass, fit neatly into the panel module. With their radical new concept of design, do these houses give us a glimpse of what will eventually be the city's appearance?

Further Reading

Bendiner, Alfred. *Bendiner's Philadelphia.* New York: A.S. Barnes and Company, 1964.

Beisert, Oscar. "The Public Minded Pedestrian Street." Hidden City (hiddencityphila.org), February 13, 2014.

Burke, Bobbye, Otto Sperr, Hugh J. McCauley, Trina Vaux. *Historic Rittenhouse: A Philadelphia Neighborhood.* Philadelphia, PA: University of Pennsylvania Press, 1985.

Hogarth, Paul. *Walking Tours of Old Philadelphia.* Barre, MA: Barre Publishers, 1976.

Holl, Steven. *Pamphlet Architecture no. 9: Rural and Urban House Types.* Hudson, NY: Princeton Architectural Press, 1995.

Lafore, Laurence and Sarah Lee Lippincott. *Philadelphia: The Unexpected City.* New York: Doubleday, 1965.

Lake, Lillian M. and Silcox, Harry C. Editors, *Take a Trip Through Time, Northeast Philadelphia Revisited,* Holland, PA: Brighton Press, Inc., 1996.

Maass, John. *The Gingerbread Age.* New York: Rinehart & Company, 1957.

McAlester, Virginia Savage. *A Field Guide to American Houses: The Definitive Guide to Identifying and Understanding America's Domestic Architecture.* New York: Knopf Doubleday, 2015.

Minardi, Joseph. *Historic Architecture in Northwest Philadelphia.* Atglen, PA: Schiffer Publishing, 2012.

Minardi, Joseph. *Historic Architecture in Philadelphia: East Falls, Manayunk, and Roxborough.* Atglen, PA: Schiffer Publishing, 2011.

Minardi, Joseph. *Historic Architecture in West Philadelphia.* Atglen, PA: Schiffer Publishing, 2011.

Morley, Christopher. *Travels in Philadelphia.* Philadelphia, PA: David McKay Company, 1920.

The Rittenhouse Fitler Historic District Manual: A Guide for Property Owners. Philadelphia, PA: Preservation Alliance for Greater Philadelphia, 1998.

Shivers, Natalie W. *Those Old Placid Rows: The Aesthetic and Development of the Baltimore (Maryland) Rowhouse.* Baltimore, MD: Maclay & Associates, 1981.

Taylor, Frank H., Editor. *The City of Philadelphia as it Appears in the Year 1894: A Compilation of Facts Supplied by Distinguished Citizens for the Information of Business Men, Travelers, and the World at Large.* Philadelphia: Geo. S. Harris & Sons, 1894.

WPA Guide to Philadelphia: A Guide to the Nation's Birthplace. Philadelphia, PA: Federal Writer's Project, 1937. Reissued with Foreword by E. Digby Baltzell, University of Pennsylvania Press, 1988.

Williams, Talcott. "Philadelphia: A City of Homes." *St. Nicholas, an Illustrated Magazine,* The Century Co., Volume 20, 1893.

Index

Page numbers in italics refer to illustrations.

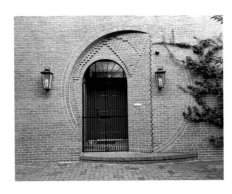

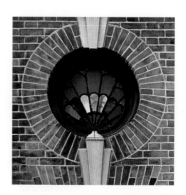

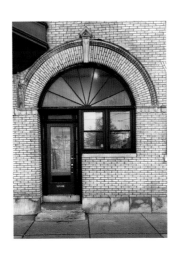

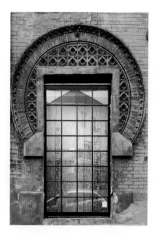